French Illuminated Manuscripts

**IN THE
J. PAUL GETTY
MUSEUM**

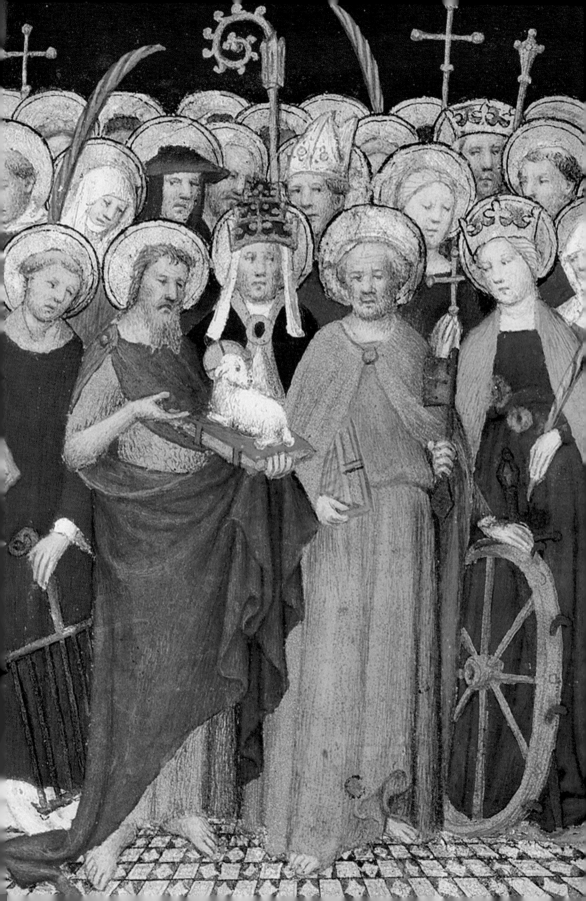

French Illuminated Manuscripts

IN THE
J. PAUL GETTY
MUSEUM

Thomas Kren

THE J. PAUL GETTY MUSEUM
LOS ANGELES

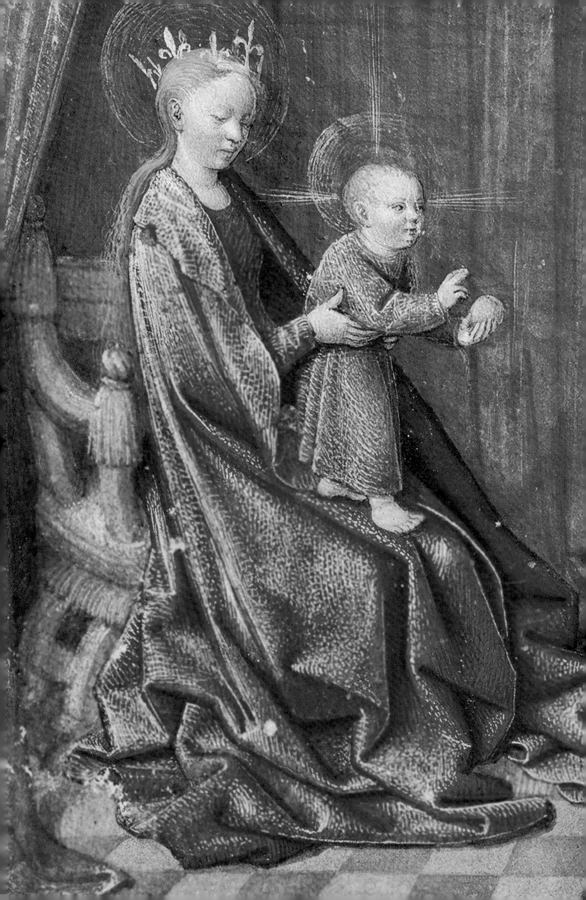

FOREWORD

This second volume in a series for the general reader about the J. Paul Getty Museum's extraordinary collection of illuminated manuscripts celebrates the achievement of French manuscript illumination in the Middle Ages. While the notion of French medieval art often brings to mind the great cathedrals with their monumental stained-glass windows, manuscript illumination was one of the most prized art forms of its time, as well as an enduring tradition in France. From a Carolingian Bible of the ninth century to a diminutive devotional book of the eighteenth century, the Getty Museum's collection opens up a world of paintings of exceptional quality that remains little known to museumgoers and other students of the period. Even in the fifteenth century, which saw the rise of the art of painting in oil on panel, manuscript illumination continued to enjoy a privileged position at the courts of France. Moreover, as so many French wall paintings and panel paintings of the period have been lost or badly damaged, manuscript illumination provides the best record of the astonishing accomplishment of French medieval painting. Due to the vagaries of time, we are often able to take the true measure of artists such as Jean Fouquet, Jean Bourdichon, the Boucicaut Master, Barthélemy d'Eyck, the Limbourg Brothers, and other great masters only through their work on the pages of manuscripts.

I am grateful to many people for realizing this project. Dr. Thomas Kren, Curator of Manuscripts at the Getty Museum since the establishment of the collection in 1983, compiled this volume and is responsible for the Department of Manuscripts' rich program of publications and exhibitions. The Museum's Imaging Services Department, in particular Rebecca Vera-Martinez, Chris Allen Foster, Michael Smith, and Stanley Smith, worked diligently to create the beautiful images in this volume. Patrick Pardo, Amita Molloy, Vickie Karten, Karen Schmidt, and Deenie Yudell of Getty Publications all played critical roles in bringing this volume to life.

Michael Brand
Director

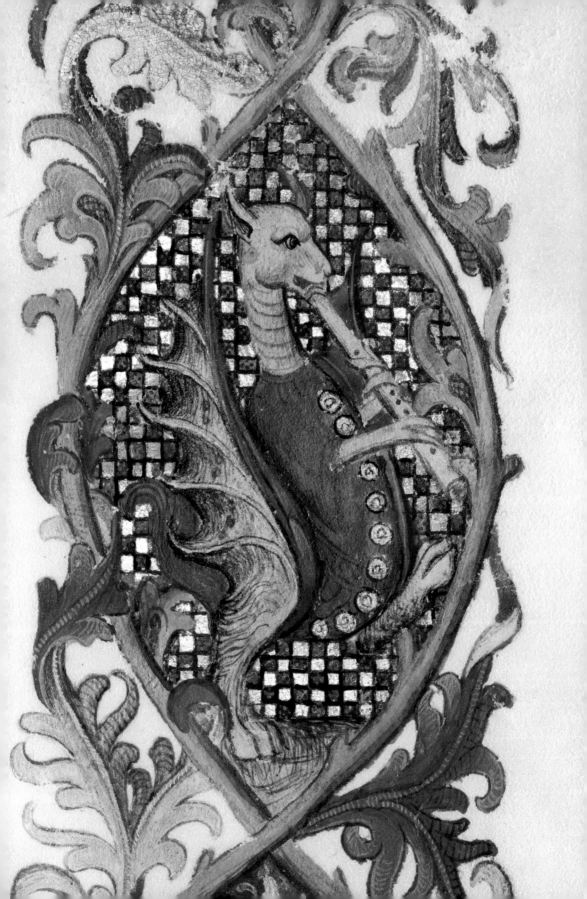

INTRODUCTION

In the early fourteenth century, Dante Alighieri (1265–1321) paid tribute in the *Divine Comedy* to "the art in Paris they call illumination." Residing in Florence, where the art of manuscript illumination also flourished at the time, the immortal poet, by his very mention of Parisian manuscript illumination, provided an indication of its fame. His notice, moreover, reflected a vital truth. Paris was then the capital of France, a locus of a wide-ranging artistic production, and the greatest center of manuscript illumination in all of Europe. Yet Dante's comment documents only one epoch and a single place in a brilliant manuscript tradition that endured over a thousand years across France. From the reign of Charlemagne (r. 800–814) through Dante's lifetime — a span of nearly six hundred years — innovative centers of manuscript illumination had sprung up in different parts of the vast geographic area that make up modern France; by this point, the hegemony of Paris as a center of illumination had already been established for several generations. Moreover, despite this achievement, some would argue that the best in French manuscript illumination was yet to come. The later fourteenth and the fifteenth centuries witnessed a nearly continuous cycle of innovation and the creation of a string of masterworks that are beloved throughout the world. The demand for luxurious manuscripts on the part of princely libraries contributed significantly to this development. While the manuscripts illuminated in the following centuries — into the eighteenth century — were less dazzling, they help show that manuscript illumination occupied a significant place in the arts of France for nearly a millennium.

This volume offers an overview of this history from the vantage point of a single collection that only was formed in the past two generations. The J. Paul Getty Museum began acquiring illuminated manuscripts in 1983 with the purchase of the distinguished holdings of European illuminated manuscripts of Peter and Irene

Ludwig of Aachen, Germany. Their collection, established over the previous quarter century, included illuminated manuscripts from the ninth to the twentieth centuries that are representative of most areas of Europe. It has provided a strong foundation that has been steadily enlarged. The Getty Museum's aim is to illustrate as many of the significant aspects of the history of manuscript illumination as possible: the most original and creative epochs, important centers, great artists, and popular texts. While the collection presented in this volume devoted to the Getty's French manuscripts does not tell the story exhaustively, it endeavors to introduce the reader to some of the splendid achievements of the French tradition. Manuscript illumination was one of the most important artistic media in medieval France. It shows that long before the emergence of the better-known and -appreciated tradition of French painting — from Poussin to Cézanne — a much-older and comparably rich and beloved tradition of painting existed in France in the form of painting in books.

While the earliest illumination in the Getty's French manuscripts collection — a group of decorated initials on leaves from a large one-volume Bible — is relatively modest, it reflects a new tradition, which is a foundation for much that follows (p. 1). Carolingian art emerged in the late eighth century under the emperor Charlemagne and continued through the ninth century. At its core was a program, based in the court and fostered by the emperor himself, for the renewal of learning and culture throughout the realm, which, by the time of his death, extended over much of modern-day France and Germany. Books were the tools most fundamental to its success. The Carolingian cultural revival not only resulted in a tremendous expansion of learning but also in an elevation of the standards of book production, through the reform of script, in design and layout, and in editing. It resulted, for example, in the production of large single-volume Bibles of the type produced at Tours and represented by the aforementioned leaves in the Getty's collection. Alcuin, the abbot of Saint Martin's at Tours from 794 to 804, edited a new edition of the Bible at the emperor's behest. The stately layout of the page in the Getty example reflects the clarity in design promoted under Charlemagne. As witnessed by the crisp Carolingian minuscule, the emperor also wanted a uniform and easily legible script in the books produced throughout his domains. Thereafter, Tours became a major center for Bible production. In reviving learning and promoting the dissemination of knowledge throughout the realm, the emperor and his advisers

looked for inspiration to the art and calligraphy of late antiquity. In the decorated "P" such inspiration is evident in the lively sprouting of stylized acanthus leaves — a signature motif of ancient art — from several corners of the initial.

A feature of French art from the Middle Ages up to the modern era is its international character. From Nivardus, the illuminator of a magnificent, if incompletely preserved, sacramentary (pp. 2–4), to Picasso, talented foreign artists have traveled to France to carry out important commissions and/or establish careers. Nivardus was from Lombardy in northern Italy and was familiar with the elaborate interlace initials of his region in the Ottonian style (named for the three German Saxon emperors called Otto between 962 and 1024). Strong circumstantial evidence suggests that the sacramentary, a service book for the mass, belonged to a group of books produced for the French king Robert the Pious (r. 996–1031).

This moment represents the dawn of the Romanesque style in French book painting, evidenced by the tension between living things (human or animal) and their surroundings, the latter often treated abstractly in the sacramentary. For example, the body of Christ is contained within the rigid boundaries of the cross, which also serves as the initial "T" of the opening words of the canon of the mass (or celebration of the Eucharist), "Te igitur" (p. 4). The level of abstraction in the treatment of the setting is also evident in a full-page inhabited initial "d" from the same manuscript (pp. 2–3). (Inhabited initials are decorated letters enlivened with human and anthropomorphic figures.) There the stem of the letter (in lowercase) culminates in a profusion of leafy vines of gold and silver. The figures clambering up the vines and the ball of densely interlaced knots that make up the bulb of the "d" show the flights of fancy and the vitality of the emerging Romanesque style. Theologians justified the transformation of simple initials of the text into elaborate paintings in gold and silver as a suitable glorification of the divine word of God. The monastery of Fleury-sur-Loire, where the manuscript was illuminated, was an important center of intellectual and cultural activity in the second half of the tenth century, otherwise a period of artistic decline in France; thus it is not surprising that the seeds of a new artistic epoch would be planted there.

Manic energy is one characteristic of the inhabited initial of the French Romanesque, and a delightful one at that. The "H" in the *Decretum* by Gratian

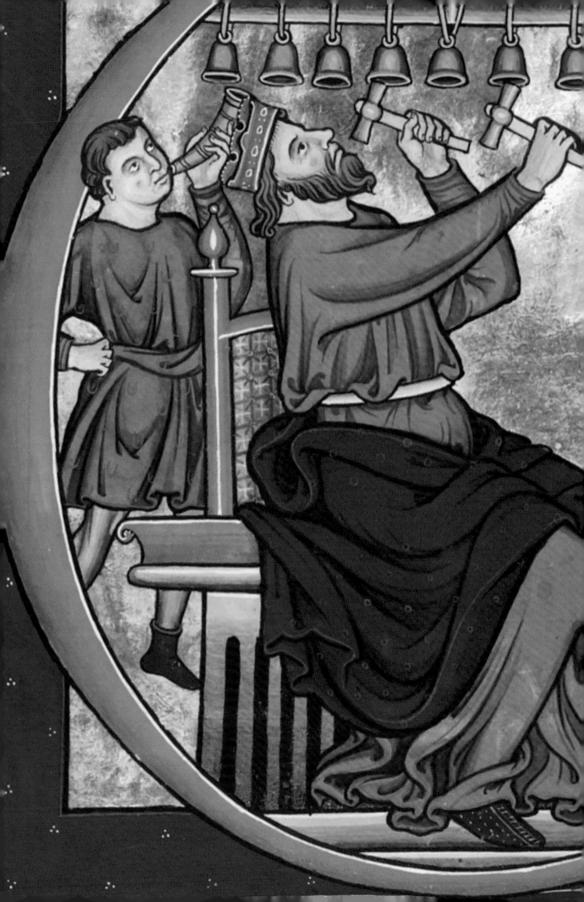

(act. ca. 1130–40), a book of church law, ca. 1170–80, is a relatively late example of the Romanesque initial. Swirling vines fill both openings of the initial (pp. 8–9). They entwine a cloaked traveler above and a centaur below, who takes aim with his bow at a griffin with a human head. For the medieval reader, as today, such inventiveness, mixing vegetation with animal and human components, often in startling juxtapositions and poses, enlivened the reading of dry texts. The *Decretum* may have been illuminated in Paris, during a period when the city had begun to grow significantly in size and stature.

Gothic painting witnessed in its very first decades, around 1200, a new response to the depiction of the human figure. Artists abandoned the rigid geometry that often circumscribed figures and confined their movements during the Romanesque. This meant depicting loose-fitting drapery that not only revealed the body beneath but also suggested greater freedom of movement. The figure of King David playing the bells in a psalter for the liturgical use of Noyon (opposite page and p. 13) was probably made in that region — located northeast of Paris — ca. 1205–10. The muscular gestures of music making engage his entire body. Apparent are the contours of the king's weighty torso underneath the robe. Sometimes this new aesthetic incorporates observation of the human figure in its natural environment, such as the extraordinary image of David, kneeling in prayer in the face of adversity (p. 14). His spiritual crisis is expressed poetically by the strong gust of wind that blows in his face, lifting up his robe and his cloak. All of these features announce a new attention to the observation of nature accompanied by a desire to heighten the physical (and three-dimensional) presence of figures in art. This luxurious psalter, made for a powerful lay patron in the circle of King Philip II Augustus (r. 1180–1223) of France, is one of the most original and accomplished examples of early Gothic illumination (see also p. 12). Its naturalism anticipates important developments in sculpture and stained glass of this time, while its monumentality may reflect the experience of a painter accustomed to working in a much-larger format, such as in wall painting or stained glass. The book's decoration belongs to a momentous flowering of the arts in Paris and the Île-de-France.

During the Middle Ages, important centers of illumination emerged across France, and manuscript production flourished. However, Philip Augustus's gradual

transformation of Paris into his administrative capital, coupled with the establishment of the university there in the thirteenth century, laid the foundation for Paris to triumph as an artistic center. It assumed a preeminent role in French Gothic book production and consequently in the art of illumination that endured for four centuries. By the death of King Louis IX (known as Saint Louis) in 1270, Paris was the greatest center of manuscript illumination in Europe.

Perhaps also painted by an artist who worked on a grander scale is a detached leaf from the Morgan Picture Bible, one of the greatest of all medieval manuscripts (pp. 16–18). Scholars disagree on whether the book was created in Paris or northern France (or even Flanders); some feel it may have been made for Saint Louis (r. 1226–70). Here the observation of nature reaches an apogee, not only in the range and quality of figural movement but also in the accumulation of telling narrative detail and in psychological expressiveness. The artists of the Bible were epic storytellers, and the witty scene of Absalom with his father's concubines on one side of the leaf and his tragic death as he gets caught in a tree and pulled from his horse on the other illustrate its range. (This Bible, when finished, had no text, reflecting the striving to relate its complex narratives entirely visually. Later owners added its various sets of captions.) The Morgan Picture Bible is one manifestation of the brilliance of French art across media by the mid-thirteenth century, from manuscript illumination to stained glass, from sculpture to architecture.

The emergence of Paris as the French capital resulted in the concentration there of a vital audience for luxury books: the king and the members of the royal family, courtiers, court functionaries, and the elite of the church. The new Gothic style of architecture had flourished throughout the second half of the twelfth century through a wealth of building in Paris and the Île-de-France, and in the thirteenth century in Paris this building boom continued: at Notre-Dame, whose Gothic facade was completed around 1200; at Saint-Denis; and at the Sainte Chapelle. These monuments in turn fostered the need for elaborate programs of stained glass, sculpture, and precious liturgical objects. Thus Parisian manuscript illumination vied for prominence within a burgeoning — indeed transformative — artistic culture that was widespread in France but centered in Paris. It was the moment that put Paris on the map as a center of art and marked the establishment of a level of creativity

that — despite the city's political ups and downs over the centuries — has endured into the modern era.

The preponderance of books produced in thirteenth-century Paris were Bibles and liturgical and devotional books. The psalter, as witnessed above, had emerged by the early thirteenth century as a favored vehicle for lay devotion, giving rise to books of unsurpassed luxury, embellished with backgrounds of gold leaf and other expensive colors. A prime example of the illuminated Parisian devotional manuscript, richly illuminated from front to back, is the Wenceslaus Psalter (pp. 19–22). The text of this psalter, the full collection of 150 psalms arranged for devotional use, is preceded by a cycle of twenty full-page paintings and a full-page historiated initial. As evidenced by the Morgan Picture Bible (pp. 16–18), a fundamental role of religious art in the Middle Ages was one of storytelling. In the Wenceslaus Psalter the division of each full-page illumination into eight entirely separate scenes facilitates exceptionally elaborate narrative cycles. They include 112 scenes from Genesis, from the Creation of the World to the story of Joseph; and twenty-four scenes from the Gospels, from the Annunciation of the birth of Christ to his Crucifixion and Resurrection. This concentration of incident within the vertical format of the page echoes the elaborate organization and tall proportions of contemporaneous stained-glass windows, which also combined numerous biblical stories, vignettes, and individual figures in roundels (circles), diamonds, and lozenges in a mosaic-like fashion.

Even as Paris rose to preeminence in the thirteenth century, manuscript illumination had flourished — and continued to do so — in other locations, notably in the prosperous region of northern France. While that region often took its artistic cues from Paris during the Gothic era, such as the highly burnished gold backgrounds of miniatures, it continued to provide new ideas along with fresh artistic blood to the capital, too. Indeed some scholars believe that, if the Morgan Picture Bible was actually produced in Paris, then its painter had moved there after learning his trade in northern France.

Probably made at Lille, in the far north of France near the modern border with Belgium, around 1270, the Getty's three volumes of a lectern Bible (pp. 26–30) likely represent half of the original set. They were intended for a Cistercian monastery at Marquette and are one of the last examples of a type of massive French Bible that

had enjoyed popularity for centuries. The book facilitated communal reading by the monks throughout the day, notably at mealtime. (During the thirteenth century, these would be supplanted in popularity by the small, portable, so-called pocket Bibles written in tiny script for students, scholars, and preachers but often still illuminated.) At the beginning of Genesis, the first book of the Old Testament, the tall slender initial "I" (pp. 26–27) contains seven scenes of the Creation of the World directly illustrating the text, but also an eighth, showing the Crucifixion of Christ. In medieval Christian theology, the meaning of Old Testament events, such as the Creation of the World, was revealed in the Gospels of the New Testament, where the story of the Crucifixion is related.

Artists from northeastern France gave particular impetus to a new fashion for marginal illuminations between 1250 and 1350. Called marginalia, illuminations in the margins sometimes complement the texts explicitly and other times represent an event that could be unrelated, a secular scene in a religious book, for example, or imagery that is simply playful, as on pages 42–43. A brilliant, characteristically charming example is a psalter from northeastern France (pp. 31–34) that also belongs to a rare type of psalter in which all 150 psalms receive narrative illumination. The illustration of Psalm 44 shows King David (considered to be the author of the psalms) playing the harp in the initial "E" (p. 31). But this is quite a small scene, and the eye is drawn readily to the charming vignette in the lower margin where an elegant queen and her finely dressed ladies-in-waiting sing from their prayer books. Meanwhile, in the upper margin, a band of angel musicians accompanies David. The rhythmic sway of the ladies' elegant postures mirrors those of the musicians above, so that the two groups, one celestial and one earthly, complement each other along with the musical theme of the initial.

Another superb example of marginalia that relates to the main illumination on the page belongs to an early-fourteenth-century book of hours that was probably also made in northeastern France (pp. 38–39). It is a scene of a hunt with a peasant blowing a horn and dogs pursuing a stag in the lower margin beneath the beautiful initial showing Judas's betrayal of Christ in the Garden of Gethsemane. The stag was often used as a symbol of Christ, and its pursuit would have called to mind the soldiers' pursuit of Christ in the initial. During the fourteenth century, the book of

hours, a collection of private devotions organized around the hours of the church day set aside for prayer (called the "canonical" hours), began to replace the psalter as the preeminent vehicle for lay devotion. The church's desire to greatly expand the participation of the congregation in daily private prayer and meditation fed the popularity of books of hours, and the demand for richly illuminated ones grew steadily among aristocratic French patrons. By the end of the fourteenth century, the book of hours was the text that consistently received the most elaborate — and usually also the most original — illumination.

Until now, little has been said about secular texts. This reflects in part a historical reality. Until the fourteenth century, luxury copies of liturgical, devotional, and other texts related to the Christian church were produced in much-greater numbers. During the twelfth and thirteenth centuries, the bestiary was popular, especially in France and England. A bestiary is a collection of tales of a broad range of animals (some thought then to correspond with real beasts that we no longer recognize today), whose particular qualities the text interprets through the prism of God's divine plan (p. 35). Not surprisingly, like so many other medieval texts that we judge today as largely secular, the bestiary still strongly reflected Christian beliefs. Accompanying the bestiary in this volume is a text called "The Wonders of the World," which purports to describe exotic peoples from the far corners of the earth, such as the curious beings on the island of Meroe that appear to be half-human and half-animal (p. 36). It reminds us that the systematic study of the natural world in the modern, scientific sense was yet to come. The volume was illuminated probably in northwestern France ca. 1277.

King Charles V of France (r. 1364–80), a patron of learning, commissioned new texts and new translations as well as beautifully illuminated copies of his books. By the time of his death, his library numbered more than 1,150 manuscripts, a remarkable sum, including works inherited and acquired by other means. It served as an important model for the princely libraries that would become such a feature of the Renaissance. The original owner of the Getty's two-volume *Historical Bible* from the era of Charles V is not known, but it is pertinent in this context because it represents a genre of text he favored and its distinctive style of illumination was also popular at court (pp. 45–46). The *Historical Bible* (*Bible historiale*) was a translation

from Latin into French, a commentary, and an expansion of Petrus Comestor's twelfth-century *Scholastic History*, a sacred history for students that also incorporated events from nonbiblical sources. Written by Guiart des Moulins between 1291 and 1295, the *Historical Bible* became a popular text in fourteenth-century France, where it was often elaborately illuminated. The Getty's copy has seventy-three miniatures, painted with minimal color in a technique called grisaille, a form of painting in hues of gray. In this book, color is limited to the faces and limbs of the figures and to the richly patterned backgrounds, which had come to replace the highly burnished gold backgrounds of the thirteenth century. Grisaille was popular throughout the four-teenth century in France and especially at the court of Charles V.

The impact of the bibliophilia of Charles V was lasting. It fostered a new era of manuscript illumination in France that featured a taste for exceptionally luxurious manuscripts, more elaborately illuminated — and more colorfully and expensively so — than ever before. Central to this development was the patronage of the king's brother John, the Duke of Berry (1340–1416). Less a bibliophile but more a connois-seur and aesthete than Charles, the Duke of Berry was probably the greatest of all French patrons of manuscript illumination. This extravagant and obsessive collector employed the famous Limbourg Brothers as his official illuminators. They created their two greatest works, the *Très Riches Heures* (Chantilly, Musée Condé) and the *Belles Heures* (New York, Metropolitan Museum of Art, The Cloisters Collection), for him. The Getty's Spitz Hours includes splendid copies of major illuminations from both of these books. They were executed by the Spitz Master, one of the few illuminators of the day who had direct access to them (pp. 72–75). The Duke of Berry was also an important patron for the illuminator Jacquemart de Hesdin (act. 1384–1413) and another known as the Pseudo-Jacquemart (act. ca. 1380–1410). The latter illuminated a portion of a once-lavish book of hours that contains an idiosyncratic and rare group of texts also found in some of the duke's devotional books (pp. 56–58). Whether the Getty hours was made for the duke is not known. *The Annunciation* and *The Birth of the Virgin* (opposite page and p. 57) illustrate the richness of color, refinement of tech-nique (note the exquisitely wrought, intricate backgrounds of the miniatures), and elegance of costume and pose in the art of Pseudo-Jacquemart. These sumptuous

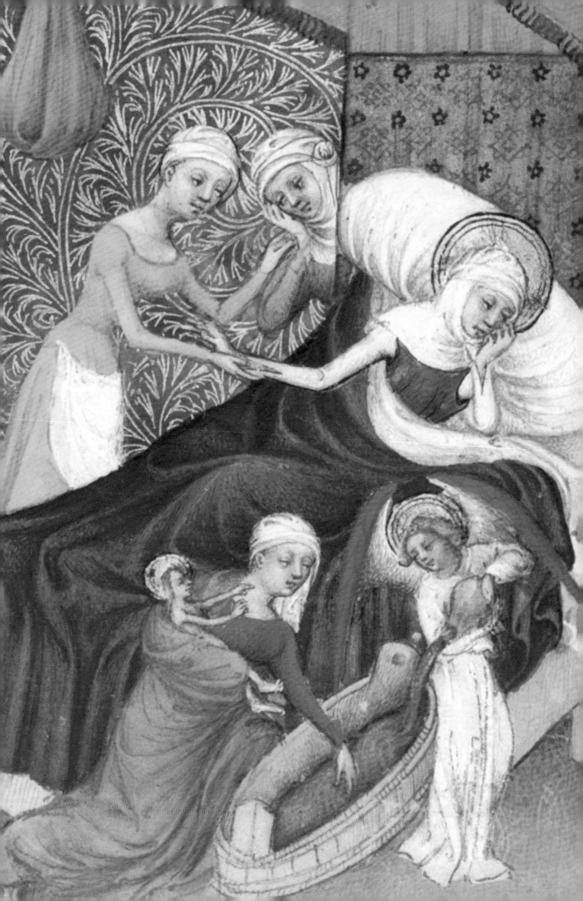

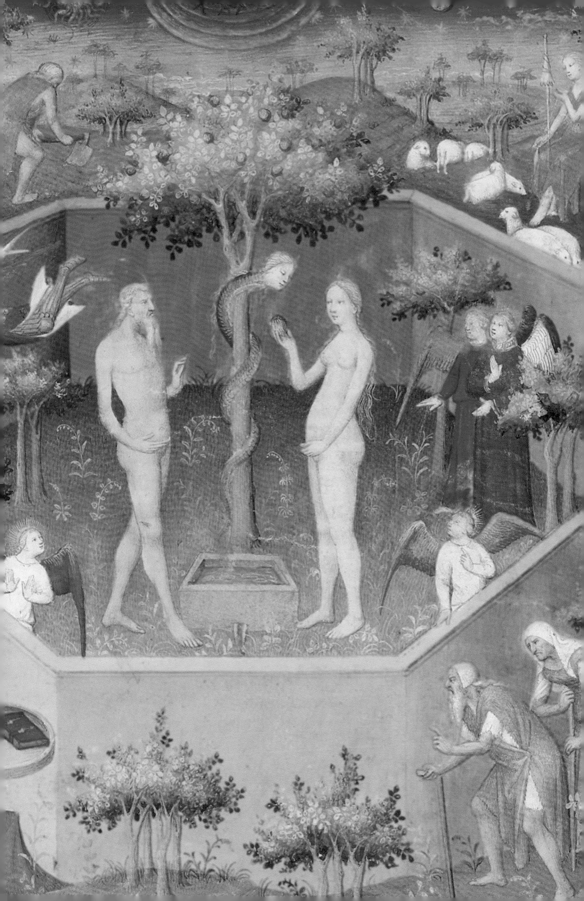

visual qualities explain the Duke of Berry's affection for this artist. Such illuminators helped to create a new style of courtly art in France.

The Limbourg Brothers were from Nijmegen in the modern-day Netherlands, and during their service to the duke they lived partly in Bourges in the Loire valley and partly in Paris. The duke himself probably spent more time in Paris, which had continued to remain a major center of book production throughout the fourteenth century and into the 1420s. During the first decades of the fifteenth century, the manuscript illumination of an anonymous artist in Paris called the Boucicaut Master was transformative, offering innovations that would shape for a generation both book painting and the rapidly emerging art of painting in oil on panel in northern Europe. The frontispiece to Boccaccio's *Concerning the Fates of Illustrious Men and Women*, ca. 1415, is one of his masterpieces (opposite page and p. 62). This large miniature tells the story of Adam and Eve from the Temptation in the Garden of Eden until they grow old. Like so many medieval artists, the illuminator was asked to provide a sequential narrative of key events in the lives of the first man and woman on earth. Rather than dividing the individual episodes into separate compartments, as we have seen up until now (pp. 16–22), the Boucicaut Master created distinct regions within a single coherent landscape setting that contains not only the enclosed Eden but also the fields around it on all sides. The walls of the hexagonal garden in turn define areas on the outside of the garden where other events take place. In the garden's center we see the Temptation, then at the left the Expulsion of Adam and Eve by an angel, and at the top left and right the couple paying for their sin with toil. Now stooped and elderly, they reappear at the lower right to approach Boccaccio at the lower left, who is dressed in a scholar's robes and ready to record the story of their lives. The splendid landscape with its deeply set horizon and atmospheric perspective heralds the importance of landscape as a theme in European art henceforth. The characterization of Adam and Eve — through posture and expression at different times of their lives — imbues the familiar story with power and poignancy. Around 1400, there were a remarkable number of gifted and inventive illuminators in Paris (pp. 48–49, 51–61, 72–75), but it was the Limbourg Brothers and the Boucicaut Master (see also pp. 62–71) who elevated French manuscript illumination to new heights of originality that, even as the form continued to flourish and innovate for another hundred years, would rarely be equaled.

Boccaccio's text also illustrates the rise of the vernacular (i.e., such regional languages as French or Italian), which in turn shaped the character of French book production in the later Middle Ages. Texts in the vernacular, such as the beloved epic allegorical poem *The Romance of the Rose* and popular historical romances such as *The Romance of the Good Knight Tristan,* reflected the tremendous expansion in literacy and the demand for texts that expressed human and historical experience, especially at the courts, whose adherents remained the most important patrons of luxury manuscripts (pp. 44, 51–52). *The Romance of the Rose* was enormously popular as both literature and a text for illumination. Of the surviving copies known, the Getty's has the most extensive program of illumination. Boccaccio wrote *Concerning the Fates of Illustrious Men and Women* in Latin. The French translation, however, enjoyed wide currency in France, where, throughout the fifteenth century, it was usually produced in deluxe illuminated copies (among which the Getty's is one of the earliest). It combines biblical and non-biblical stories of great men and women in history, starting with Adam and Eve and continuing into the early fourteenth century.

Between 1415 and 1435 civil war and the conflict between the English and the French had disastrous consequences on artistic production in Paris. By 1420 the English army would occupy the Île-de-France, Normandy, and other parts of the country; in the same year, Henry V of England (r. 1413–22) was named regent of France and based his capital in Rouen. Charles VII of France (r. 1422–61) had fled to Bourges in Berry by the time of his own accession to the throne. Royal troops did not retake Paris until 1436, and they finally drove the English out of France only in 1453. During the 1440s, Tours became the effective capital of the country, the residence of the king and his court, and the site of the royal administration. In the meantime, besides Tours and Bourges, other centers of illumination were developing in the Loire valley (see pp. 82–83).

If French manuscript illumination of the early fifteenth century represented an apogee of extravagant programs of illumination, rich color, and elegance, the mid-century introduced a more rational component to illumination and painting. This was likely inspired and sustained in part by contact with Italy, where the Renaissance was flowering. As a young man, Jean Fouquet (1415/20–1478/81) of Tours traveled to Rome, where he was exposed to the painting of Fra Angelico and may even have

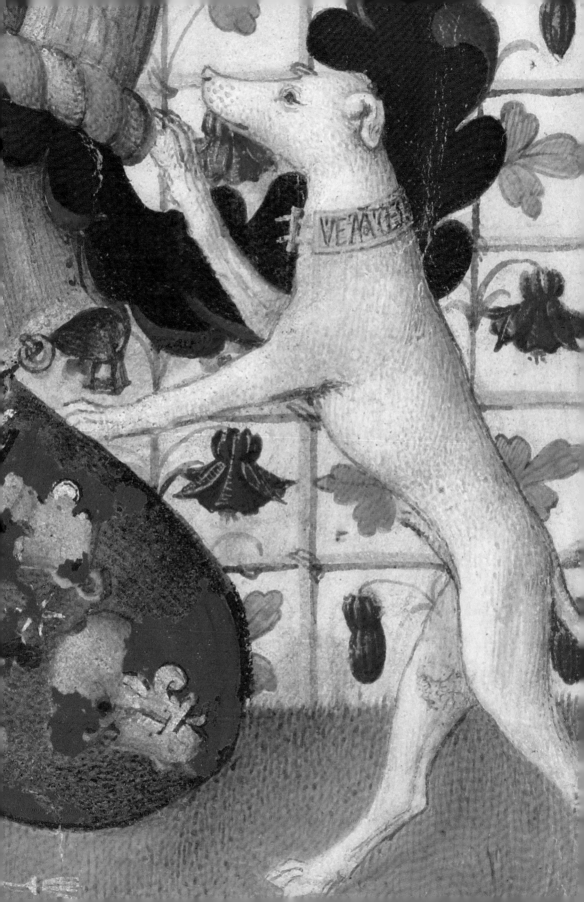

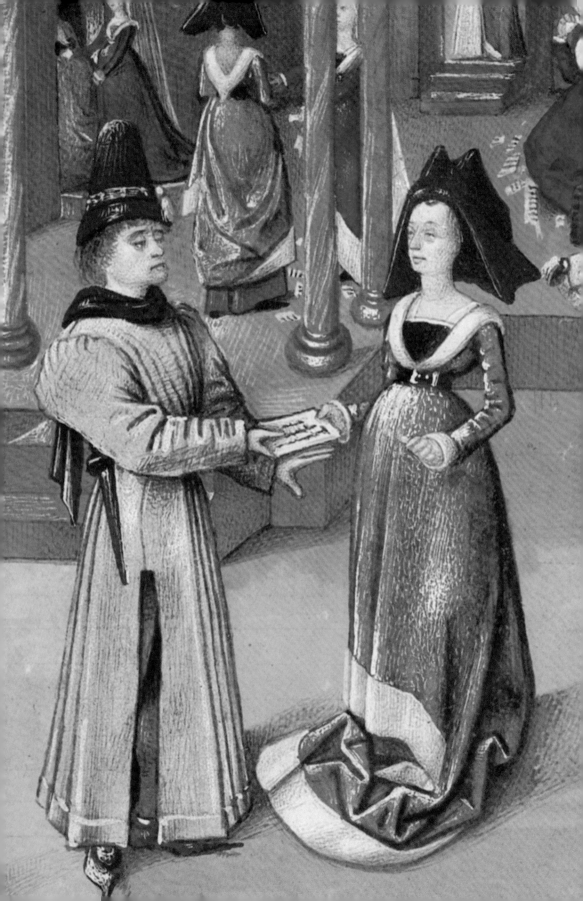

worked together with him. Fouquet was considered so gifted in the art of portraiture that while in Rome he won a commission from Pope Eugenio IV (1431–47) to paint him. Upon Fouquet's return to France, he assumed the title of court painter under Charles VII and, subsequently, under Charles's successor, Louis XI (r. 1461–83).

Although Fouquet was probably even more active as a painter than as an illuminator, few of his paintings survive, and today he is best known for his contributions to illuminated books. He is thus the first French artist whose body of work reveals how his skill as a painter informed his work as an illuminator. Portraiture had existed in French books of hours for more than a century, usually in the form of donor portraits, such as the one in the frontispiece diptych to the Hours of Simon de Varie (pp. 84–85). But Fouquet brings to the image a new level of psychological penetration as well as three-dimensionality. The fifteenth century had also seen the rise of the art of independent portrait painting across Europe, and Fouquet was one of its most original and disciplined practitioners. At the same time, this diptych shows the lessons he learned in Italy, especially the subtle use of geometry, for example, in the heads of the Virgin and Christ child and in the pyramidal shape formed by the Virgin's blue robe, which lends the figures weight, clarity, and dignity. The painted diptych was familiar, though not common, in devotional books by this late date. It was a format especially attractive to Fouquet, whose private devotional altarpieces in the form of diptychs were also in demand.

With the advent of Fouquet at the court of France, Tours blossomed as an artistic center, sustained by court patronage. Fouquet and his followers, such as Jean Bourdichon and the Master of Jean Charpentier, enjoyed favor in this circle, in which great wealth was concentrated (pp. 97–99, 105–7). Meanwhile, in Paris, artists such as the Master of Jean Rolin II, Maître François, and the Coëtivy Master (who was also a painter on panel and a designer of stained glass and tapestries) held sway (pp. 87, 94–95).

As the French gradually took back their country from the English, prosperity returned — and with it, art patronage — so that centers of illumination flourished throughout the country, not only at Tours but also at the court of René of Anjou and other places. One extraordinary painter/illuminator at the court of René was Barthélemy d'Eyck (act. 1444–72); another was a related master, the anonymous illu-

minator of *The Story of Two Lovers*. This text belongs to a collection of writings in the Getty by the young Italian humanist Aeneas Silvius Piccolomini (1405–1464), who in 1458 became Pope Pius II (pp. xxii, 89–93). *The Story of Two Lovers,* an erotic adventure that became popular across Europe, tells of Euralyus, a German nobleman who falls in love with Lucretia in the Italian town of Siena. The Getty manuscript is the only known illuminated copy of this text. A large miniature illustrates an early moment in the story: Euralyus sending a letter to his beloved by means of a female go-between (pp. xxii, 93), with Euralyus in the left foreground and the go-between to the right of him. The illuminator stages subsequent incidents in the same interior, with the characters reappearing in the same dress. The go-between delivers the letter to Lucretia (dressed in a blue gown behind a post in the middle of the picture). Offended by the poor reputation of the intermediary, Lucretia tears the letter up without reading it, and in the far doorway the go-between meets Euralyus again to report what has transpired. Lucretia (at right) quickly regrets what she has done and pieces the letter back together. The illuminator's deft delineation of the figures, both physically and psychologically, along with the lucid narrative incorporating many vignettes within a relatively confined space, epitomizes the new order, clarity, and subtlety of French manuscript illumination in the era of Fouquet.

Jean Bourdichon (1457/58–1521) succeeded Fouquet as court painter to Louis XI and in this capacity provided paintings, illuminations, decorations for royal festivities, and even the death mask of a pious monk, Saint Francis Paola, who was close to the royal family. Today nearly all that survives from Bourdichon's long service — he served four successive French rulers as court painter — are illuminated manuscripts (pp. 98–99, 105–7). To judge from the great quantity, it must represent a significant portion of his productivity over a forty-year period. An early book of hours from the hand of Bourdichon reveals him as a skillful, even eloquent interpreter of Fouquet's art (pp. 98–99), and his success at court may have resulted from his ability to continue that tradition. After some decades, however, Bourdichon endeavored to create still weightier, more monumental figures, possibly in response to the interests of Charles VIII (r. 1483–98) and Louis XII (r. 1498–1515) in Italian art. An example is the book of hours he illuminated for Louis XII shortly after his accession to the throne (pp. 105–7). The type of the kneeling king, one-half of a

diptych in which the facing miniature is lost, follows the format of Fouquet's diptych (pp. 84–85). The sensual miniature of Bathsheba bathing, probably based on a lost miniature by Fouquet, shows that devotional books could occasionally be both witty and titillating. The feline face of the waterspout stares at the beautiful blonde's genitalia even as she directs her charms proudly to the viewer, the original of whom was, of course, the king himself.

Neither the rise of painting in oil on panel as an artistic medium in the fourteenth and fifteenth centuries nor the introduction of printing with movable type in the 1450s (first in Germany) spelled the demise of manuscript illumination. In fact, the era witnessed the growth of princely libraries; for the highest-ranking princes, following the example of Charles V of France and John, the Duke of Berry, lavishly illuminated books embodied their taste and authority. Especially at court, the status of manuscript illumination among the visual arts remained high. Indeed, even as the production of extensively illustrated printed books (with woodcuts) established itself firmly in Paris in the 1480s, the demand for luxurious devotional manuscripts remained strong, among both members of the ruling households and their courtiers. It was the best manuscript illuminators who also obtained the titles of court painter, court illuminator, and/or *valet de chambre* (a court retainer) — individuals like Fouquet, Bourdichon, Barthélemy d'Eyck, and Georges Trubert (pp. 84–86, 98–99, 103–7). Trubert (act. 1467–1508) was court illuminator successively to René d'Anjou and then to René II of Lorraine. As we have seen, most of these artists were not solely illuminators but also worked in a variety of media, such as painting in oil on panel, tapestry design, stained glass, embroidery, and metalwork. Artists who fit into this category include Fouquet, Bourdichon, the Coëtivy Master (p. 95), and Antoine de Lonhy (p. 88).

Lonhy (act. 1446–ca. 1490), an intriguing artist, appeared at the beginning of his career in Autun in Burgundy, then moved to Toulouse, followed by a project in Barcelona. He finally settled in the Piedmont region of northern Italy, part of the duchy of Savoy with close connections to France. He received commissions for manuscript illumination, designs for stained glass, panel paintings, and frescoes, too. The breadth and dignity of his sympathetic *Christ in Majesty* (p. 88), once part of the canon pages of a missal, show his strong French roots — above all in the composition and the heavenly sky carpeted in golden stars.

Throughout the fifteenth century, gifted artists continued to leave their homes in foreign lands to work in France. In the first decades of the century, the Limbourg Brothers were joined by Jacques Coene, a painter from Bruges (in modern-day Belgium), whom some scholars believe may be identical with the Boucicaut Master. Barthélemy d'Eyck belonged to an artistic family from Maaseyck in the Netherlands and may have been born there. At the beginning of the sixteenth century, a certain Noël Bellemare (act. 1512–46) received his training in Antwerp, where he absorbed the tenets of two burgeoning schools of painting in that city: the Mannerists and the landscape specialists. The former is an art steeped in the examples of Italian High Renaissance painters such as Michelangelo and Raphael. The latter emerged in the first two decades of the sixteenth century, as a group of artists in Antwerp became the most innovative landscape painters in Europe. Thus, Bellemare transported a polyglot style to Paris, where he executed commissions for manuscript illumination, large altarpieces, and stained glass. The glass can still be seen in the church of Saint Germain l'Auxerrois opposite the Louvre. He was also commissioned to create decorations for the triumphal entries of Queen Eleanor in 1531 and Emperor Charles V in 1539. In 1526 the Parlement designated him *peintre et enlumineur juré* (sworn painter and illuminator) of the city of Paris in conjunction with a commission for an illuminated calendar. Today most scholars believe he headed a large workshop of illuminators—the most important in Paris— known as the 1520s Hours Workshop. The Master of the Getty Epistles was a key artist within this group and may himself be identical with Bellemare. His figure of Saint Paul (p. 109) wears a robe in the ancient style as imagined by the artists of the Italian High Renaissance. Especially alluring is the splendid vista behind the saint inspired by the motifs (including ruins) and atmospheric effects of the Antwerp school of landscape painting.

For all intents and purposes, the great French tradition of manuscript illumination, still closely tied to Paris and connected to the royal court, wound down during the course of the sixteenth century (p. 110). Yet manuscript illumination, which was waning across Europe, reappeared sporadically in France, especially at court and in royal circles into the eighteenth century. Two artists illustrate its persistence in France, the first being Jacques Bailly (1634–1679), a miniaturist known for his flower pieces. In 1663 he was admitted to the French Academy and in the same year entered the service of Louis XIV

un Dauphin qui se joüe sur une mer calme, avec c

TVENDVS.

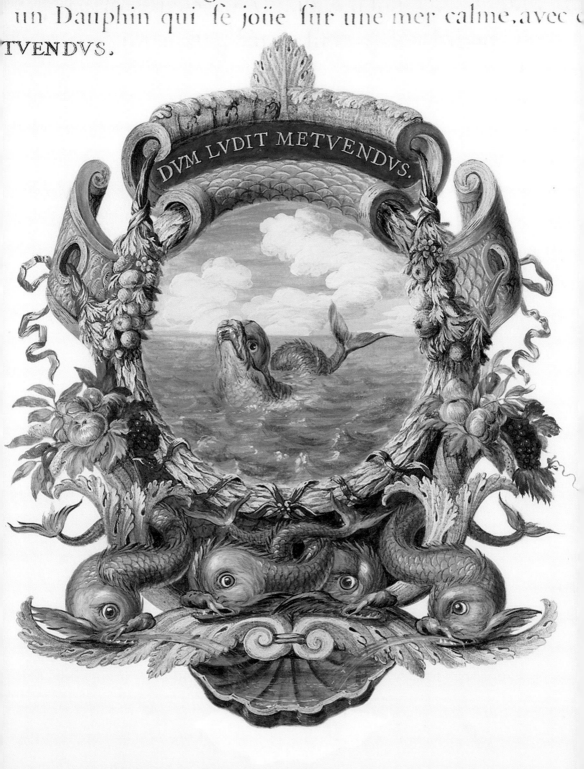

DVM LVDIT METVENDVS.

Dans le sein de son vaste Empire,

Où tout repose en paix jusqu'au moindre Zep

On le voit s'ébattre & sauter ;

(r. 1643–1715). In 1667, as *peintre ordinaire des bâtiments du roi* (court painter working on royal commissions), Bailly directed his attention to the designs of royal emblems for a set of tapestries celebrating the triumphs and virtues of Louis XIV, of which the Getty owns twelve leaves (pp. xxvii, 112–13). More traditional is the work of Jean Pierre Rousselet in the 1720s and 1730s, seen in the collection of prayers for the mass, a private devotional book — small enough to fit in the hand — that is an elegant descendant of the luxury books of hours of the fifteenth century. Indeed the devotional books produced by Rousselet were embellished with the same stories from the life of Christ (p. 111). Its illuminations are, however, very much of the moment in capturing the color, light, and quality of movement of the Rococo period. Not surprisingly, Rousselet seems to have specialized in such works for aristocratic patrons close to the court.

 The tradition of manuscript illumination in France is an extraordinary one. For a thousand years, book painting flourished there, often within the environment of the court, but also throughout the realm, usually as a result of court programs or indirectly inspired by the court example. During the thirteenth century, Paris emerged as the preeminent center of manuscript illumination in all of Europe. Manuscript illuminators were not only among the most original artists of the Middle Ages and the Renaissance in France, but some also rose to official positions within the households of kings, dukes, and other ranking nobles. Manuscript illumination was, in short, one of the most important artistic media and provides the most complete and moving evidence of the achievements of painters in France during the Middle Ages. These artists have left us many of the greatest European illuminated manuscripts.

T he Getty's collection of manuscript illumination began with the purchase of the distinguished holdings of Peter and Irene Ludwig in 1983. From 1957 until 1980, the Ludwigs acquired many of the finest illuminated manuscripts to appear on the art market. Indeed the series of sales of the manuscripts of C. W. Dyson Perrins, who had assembled one of the great collections of illuminated codices in the first half

of the twentieth century, gave a powerful impetus to the Ludwigs' collecting. As a result, in the area of French illumination, the Ludwigs purchased such treasures as the royal sacramentary from Fleury-sur-Loire, the Gratian *Decretum*, and the High Gothic Wenceslaus Psalter. Over the decades, they took advantage of many other splendid opportunities to enrich their French holdings. A second important series of their French purchases had belonged earlier in the century to another distinguished English collector, Sir Sydney Cockerell, the great scholar and connoisseur of manuscripts and former director of the Fitzwilliam Museum. These included the Marquette Bible, the Ruskin Hours, and the leaf from the Morgan Picture Bible. By the time the Ludwigs ceased collecting manuscripts, their French holdings encompassed significant examples from the ninth to the sixteenth centuries.

At the time of the Getty's purchase of the Ludwig collection, there were some experts who remarked that this was the last major collection that an American institution might hope to buy and that major opportunities would be increasingly few. This has, to a degree, been true. A number of our most important acquisitions since then have come not from the great collections of illuminated manuscripts but rather either from bibliophiles who owned but one significant example of book painting or from art collectors whose focus was largely on other media. The former was the case, for example, with the Hours of Simon de Varie, with its four exquisite miniatures by Jean Fouquet, from the collection of the bibliophiles and numismatists Mr. and Mrs. Gerald F. Borrmann of California; and with the Katherine Hours, a key early manuscript by Jean Bourdichon from the Carl H. Pforzheimer Library in New York. Previously overlooked, forgotten, or unrecorded works have also figured significantly in strengthening the collection. The Borrmanns acquired the Hours of Simon de Varie as a beautiful French book of hours and were initially unaware that some of its miniatures were by Fouquet. They were eager that their treasure remain in a California collection. The psalter for the use of Noyon was last recorded in the eighteenth century before it appeared in a provincial auction in France in 1986, which caused a stir in the art world, as a major monument of early Gothic art had reemerged. The whereabouts of Aeneas Silvius Piccolomini's *Story of Two Lovers* had been unknown since the mid-nineteenth century, when one of the greatest of all bibliophiles, the Duc d'Aumale, purchased it for a friend, Armand Bertin. Bourdichon's magnificent donor portrait of Louis XII of

France, shown publicly only once since 1920, was among artworks recuperated by the Rothschild family of Paris after the Second World War.

Over the course of the past several decades, the art market has been much richer in the illumination of the later Middle Ages than of earlier periods. As a result, books or individual illuminations by the Boucicaut Master, Pseudo-Jacquemart, the Spitz Master, the Coëtivy Master, Maître François, and Georges Trubert have found their way into the collection.

American museums and libraries — and their patrons — have avidly collected French medieval art, including manuscript illumination, over the past one hundred years (as have their European counterparts). Not surprisingly, many significant works, besides the Hours of Simon de Varie and the Katherine Hours, have been acquired specifically from American collections. Antoine de Lonhy's imposing *Christ in Majesty* had been in an American collection since the early twentieth century but only returned to public view in 1993. It was a generous gift to the Getty from Rev. James and Dr. Margaret Emerson. The famous Boccaccio illuminated by the Boucicaut Master and his workshop was acquired by H. P. Kraus in 1980 and sold to an American collector who subsequently sold it to us. The Getty also purchased directly from the owner of the Spitz Hours, another major French manuscript that had been in the collection of an American family for several generations.

While such a young collection as the Getty's cannot offer a comprehensive overview of French manuscript illumination over ten centuries, our collection hopefully offers an informative introduction to a brilliant and still-underappreciated artistic medium. At the Getty we view the history of manuscript illumination as part of the larger tradition of European painting. We are proud to be able to represent the history of French painting from Nivardus to Cézanne and believe that the appreciation of the one medium only enhances and enriches the visitor's understanding of the other.

Thomas Kren
Curator of Manuscripts

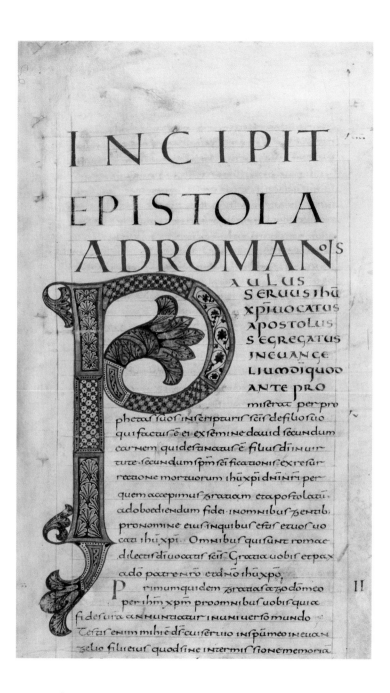

Decorated Initial P

Fragments of a Bible, leaf 10
Tours, ca. 845
Leaf: 46.3 × 33.8 cm (18 ¼ × 13 ⁵⁄₁₆ in.)
Ms. Ludwig I 1; 83.MA.50

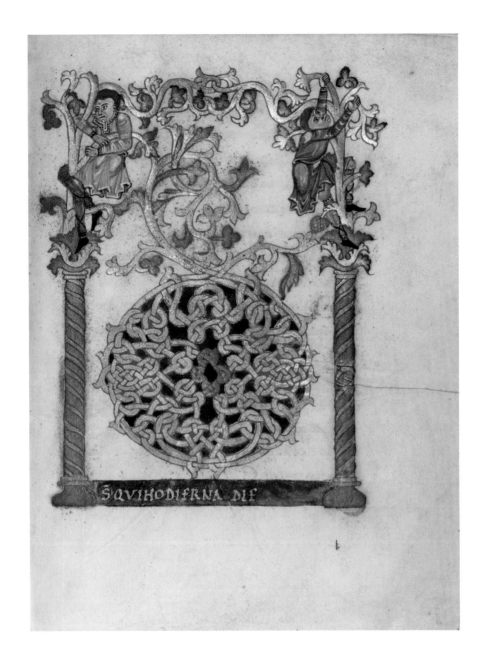

Nivardus of Milan | Decorated Initial D (with clambering figures)

Sacramentary, fol. 9 and detail
Fleury, first quarter of the
eleventh century
Leaf: 23.2 × 17.8 cm (9⅛ × 7 in.)
Ms. Ludwig V 1; 83.MF.76

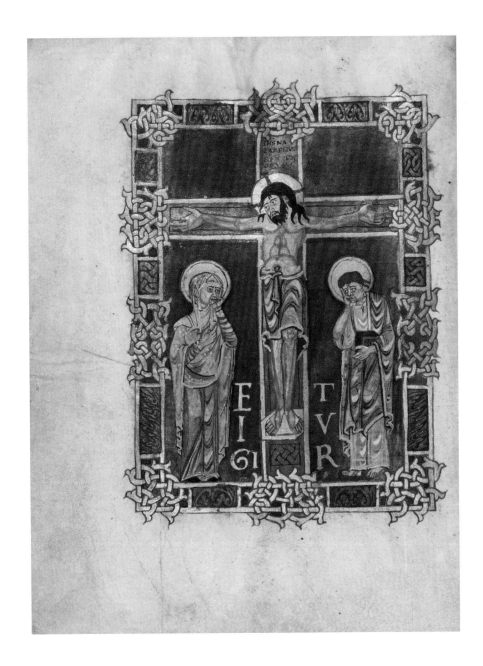

Nivardus of Milan | The Crucifixion

Sacramentary, fol. 2v

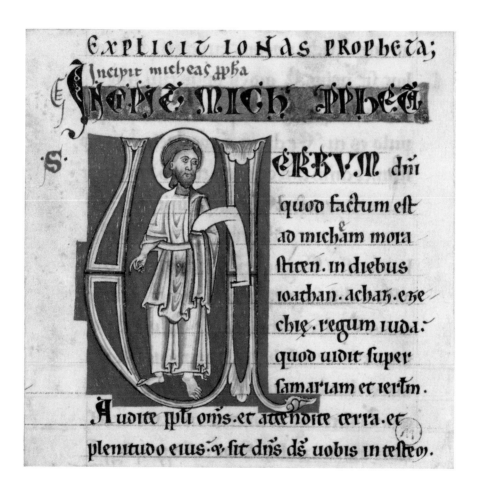

Initial V with The Prophet Micah

Cutting, probably from a Bible
French, ca. 1131–65
Cutting: 13.7 × 13.5 cm (5 ⅜ × 5 ⁵⁄₁₆ in.)
Ms. 38; 89.MS.45

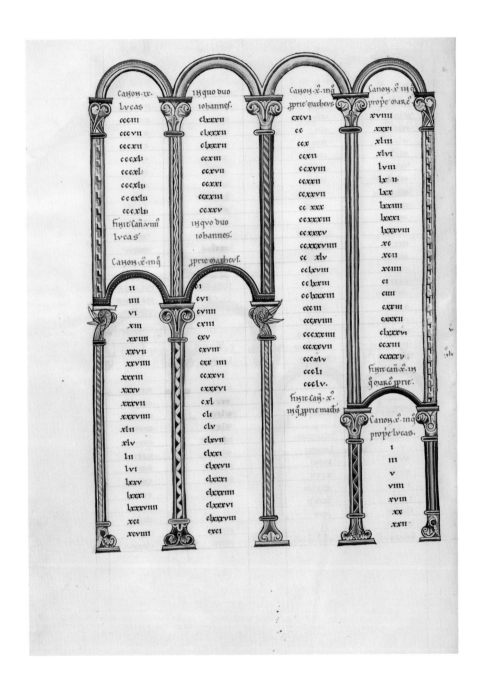

Canon Table

New Testament with the Canons of Priscillian, fol. 16v
France, probably Cistercian Abbey of Pontigny, ca. 1170
Leaf: 43.5 × 31.5 cm (17 ⅛ × 12 ⅜ in.)
Ms. Ludwig I 4; 83.MA.53

uolo manere: donec ueniam. Quid
ad te. Tu me sequere. Exiuit ergo
sermo iste inter frs: quia discipls
ille ñ moritur. Et ñ dixit ei ihc qa
non moritur. S; sic eum uolo ma
nere donec ueniam: quid ad te.
Hic e discipulus ille qui testimo
nium phibet de his: et scripsit hec.
Et scimus quia uerum e testimoni
um eius. Sunt autem et alia mul
ta que fecit ihc: que si scribantur
p singula. nec ipsum arbitror
mundum capere eos qui scriben
di sunt libros. Explicit euuglin
Secundum iohannem.

EXPLICIT LIBER

EUUAHGELIORUM.

Incipit plogus sci ieronimi prbi
in actus apostolorum.

fr. ii. post oct pasche
lco pma

Lucas natione syrus
cuius laus in euangelio canitur:
apud antiochiam medicine ar
tis egregius. et aplorum xpi dis
cipulus: postea usq; ad confessi
onem paulum sequutus aplm:

Initial L with The Ox of Saint Luke

*New Testament with the Canons
of Priscillian, fol. 95 (detail)*

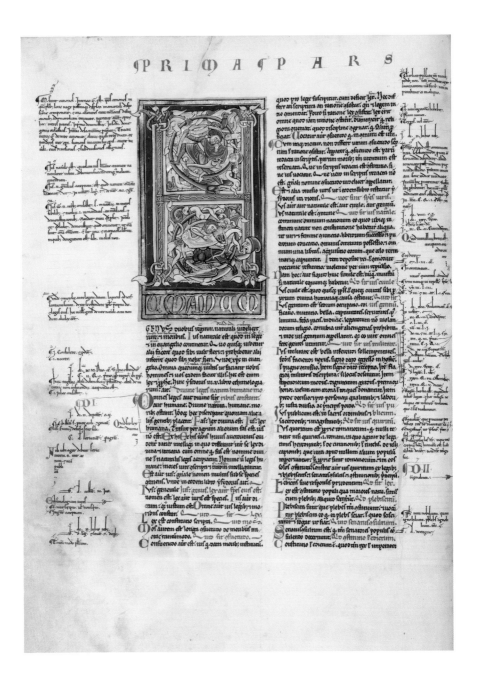

Inhabited Initial H

Gratian, *Decretum, fol. 8v and detail*
Paris or Sens, ca. 1170–80
Leaf: 44.2 × 29 cm (17 7/16 × 11 7/16 in.)
Ms. Ludwig XIV 2; 83.MQ.163

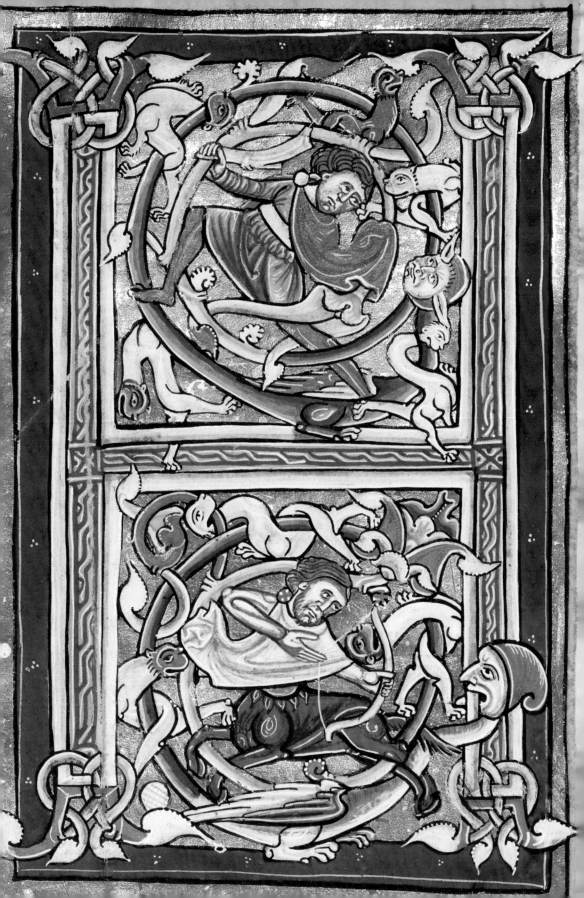

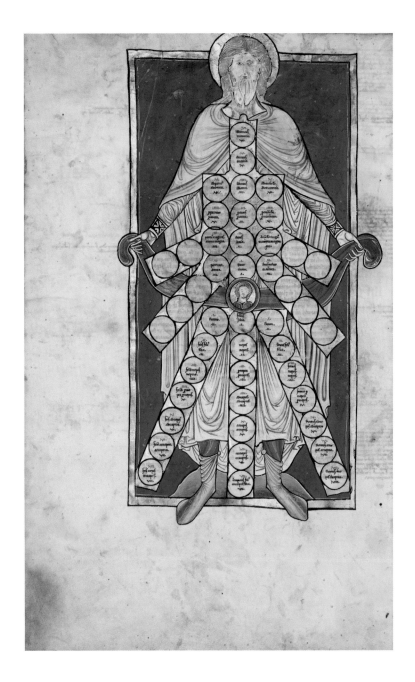

Table of Consanguinity

Gratian, Decretum, fol. 227v

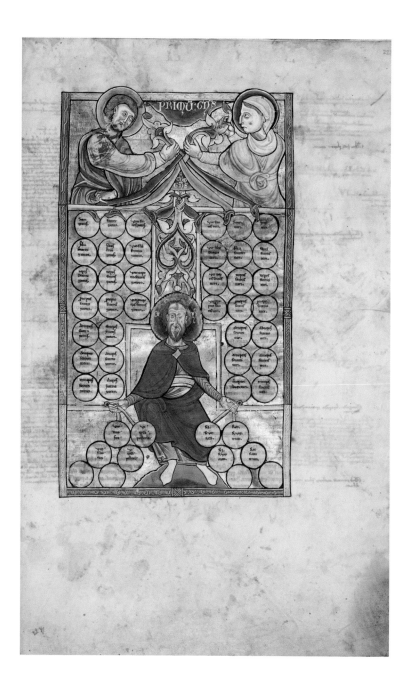

Table of Affinity

Gratian, *Decretum, fol. 228*

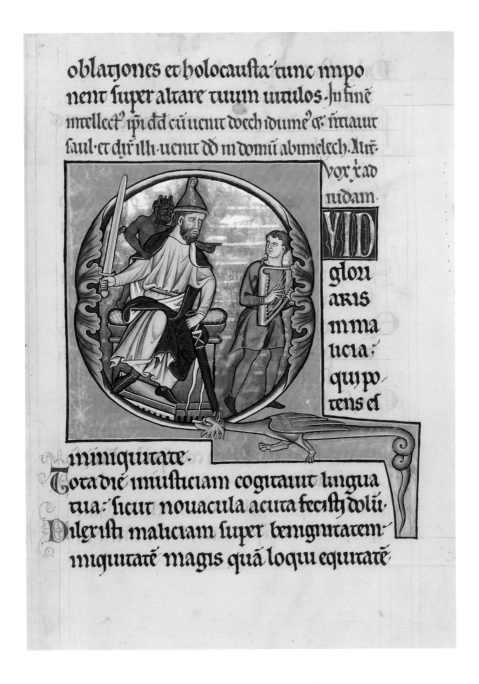

oblatiomes et holocausta tunc impo
nent super altare tuum uitulos. In fine
intellect ipi dd cum uenit doech idume⁹ et nunauit
saul et dixit illi uenit dd in domu abimelech. Aut

vor icad
nidam.

VID
glori
aris
in ma
licia:
qui po
tens es

in iniquitate.
Tota die iniusticiam cogitauit lingua
tua: sicut nouacula acuta fecisti dolu
Dilexisti maliciam super benignitatem.
iniquitate magis qua loqui equitate

Master of the Ingeborg Psalter | Initial Q with David and Saul

Leaf from a psalter, fol. 55
Probably Noyon, after 1205
Leaf: 30.8 × 21.5 cm (12 ⅛ × 8 ½ in.)
Ms. 66; 99.MK.48

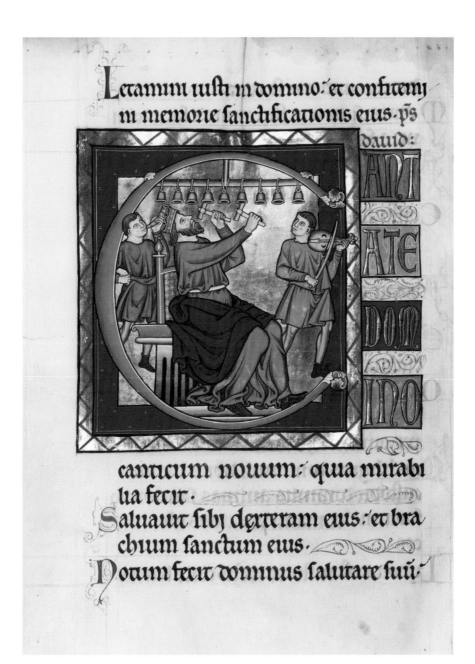

Letamini iusti in domino: et confitemini
in memorie sanctificationis eius. ps
dauid:

canticum nouum: quia mirabi
lia fecit. Saluauit sibi dexteram eius: et bra
chium sanctum eius. Notum fecit dominus salutare suu

Master of the Ingeborg Psalter | Initial C with David Playing the Bells

Leaf from a psalter, fol. 105v

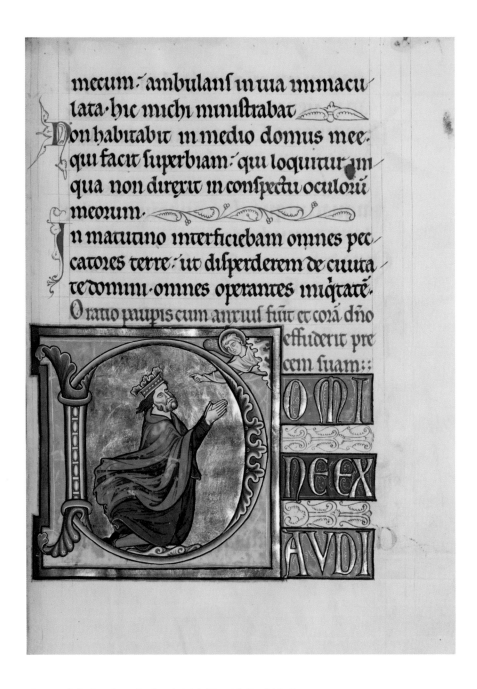

mecum ambulans in uia immacu
lata hic michi ministrabat
Non habitabit in medio domus mee.
qui facit superbiam qui loquitur in
qua non direxit in conspectu oculorū
meorum
In matutino interficiebam omnes pec
catores terre ut disperderem de ciuita
te domini omnes operantes iniqtatē.
Oratio pauperis cum anxius fuit et corā dño
effuderit pre
cem suam:
DOMI
NEEX
AVDI

Master of the Ingeborg Psalter | Initial D with David in Prayer

Leaf from a psalter, fol. 108

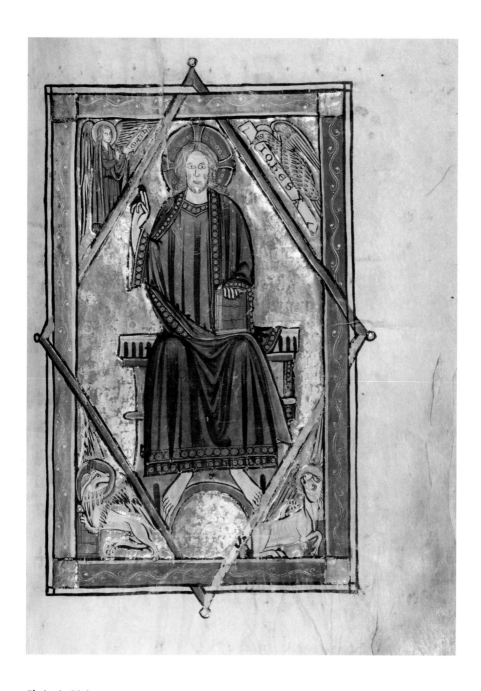

Christ in Majesty

Missal, fol. 105
Lyons, between 1234 and 1262
Leaf: 24.7 × 16.6 cm (9 ¼ × 6 ⁹⁄₁₆ in.)
Ms. Ludwig V 5; 83.MG.80

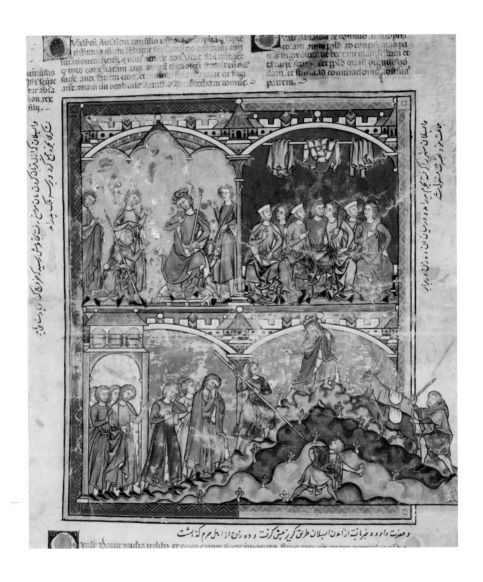

Scenes from the Story of David and Absalom

Single leaf from the Morgan
Picture Bible, recto and detail
Northern France, ca. 1250
Leaf: 32.5 × 29 cm (12 ¹³/₁₆ × 11 ⁷/₁₆ in.),
trimmed on all sides
Ms. Ludwig I 6; 83.MA.55

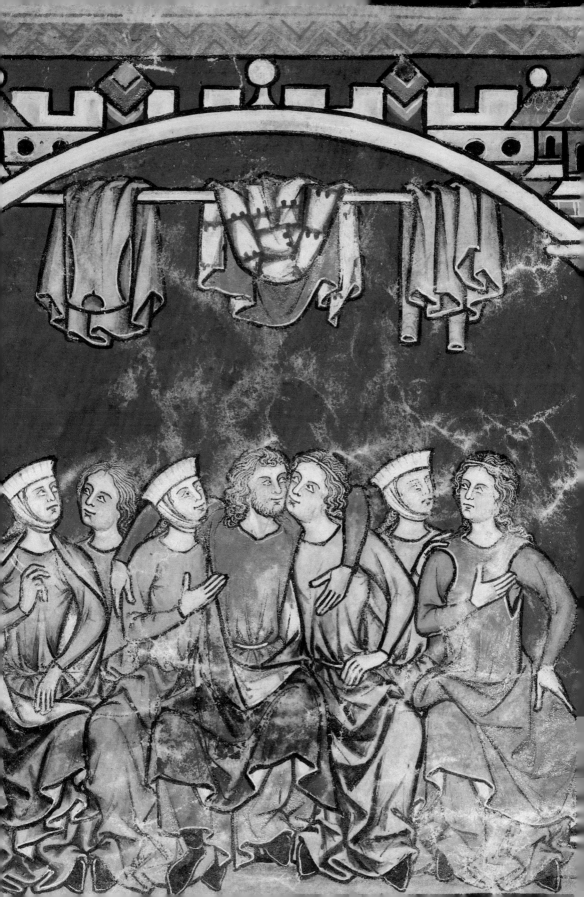

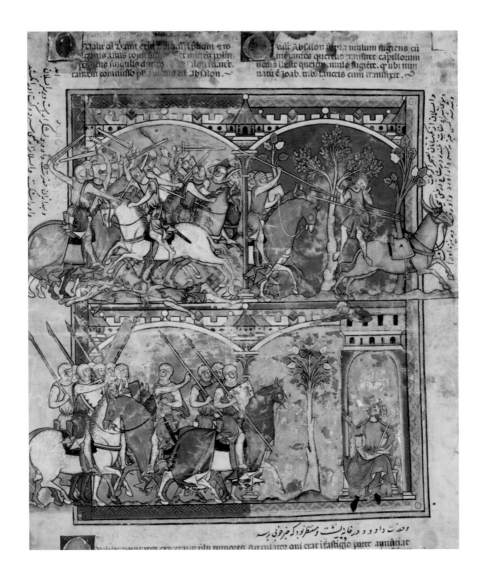

The Battle in Ephraim Forest and Scenes from the Story of Absalom

*Single leaf from the Morgan
Picture Bible, verso*

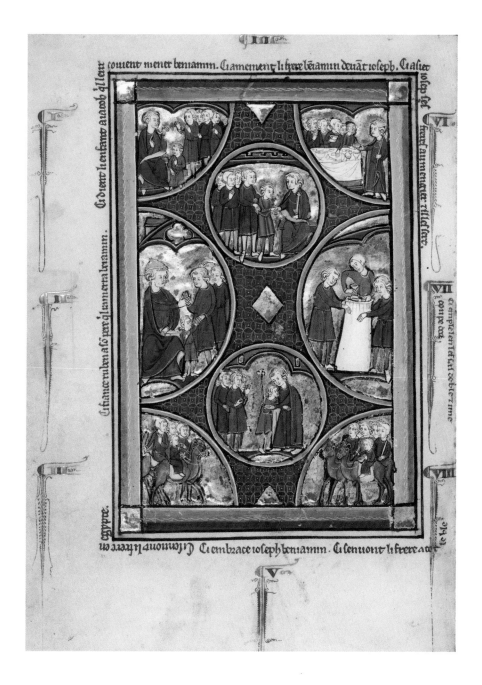

Wenceslaus Workshop | Scenes from the Story of Joseph

Wenceslaus Psalter, fol. 19v
Paris, ca. 1250–60
Leaf: 19.2 × 13.4 cm (7 9/16 × 5 1/4 in.)
Ms. Ludwig VIII 4; 83.MK.95

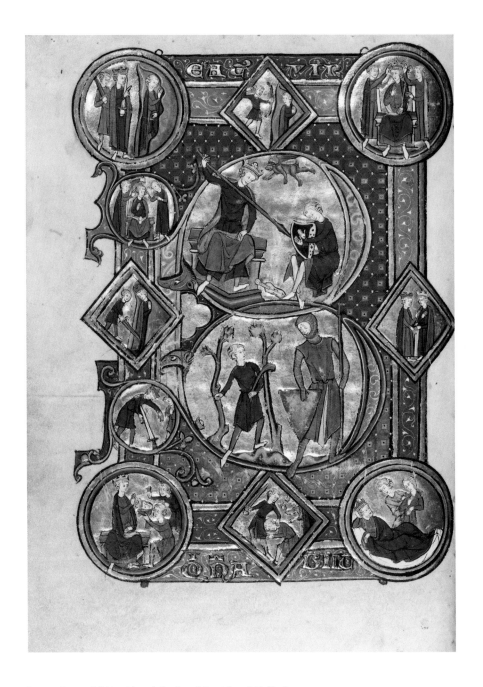

Beatus Page with David and Saul and David and Goliath

Wenceslaus Psalter, fol. 28v and detail

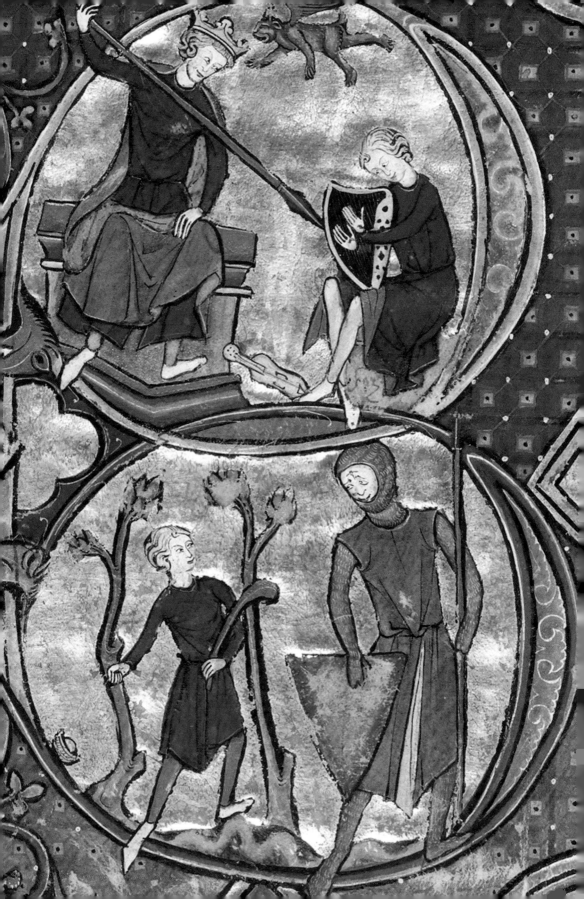

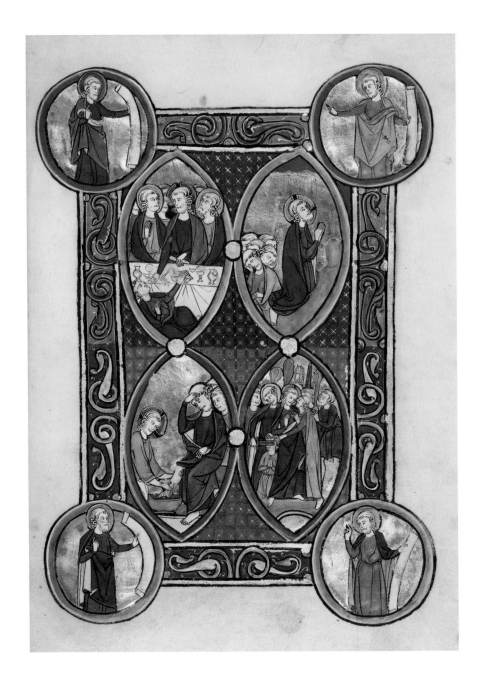

Johannes Grusch Workshop | Scenes from the Passion of Christ

Wenceslaus Psalter, fol. 26

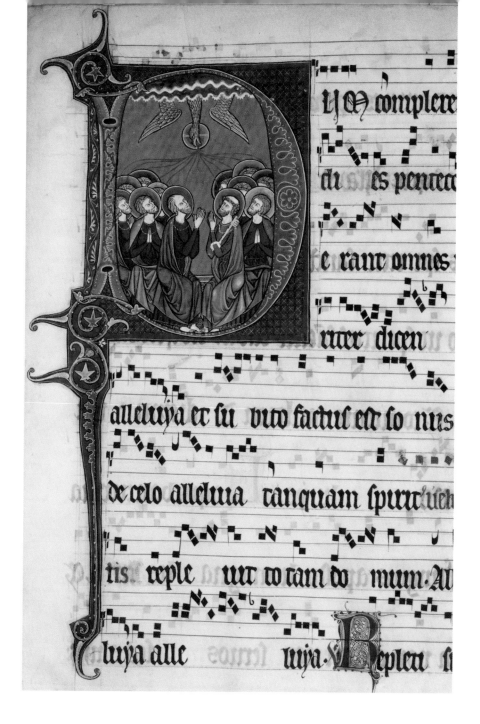

Initial D with The Pentecost

Leaf 5 (recto, p. 192) from
an antiphonal (detail)
Northeastern France or Flanders,
ca. 1260–70
Leaf: 48 × 34.5 cm (18 ¹⁵⁄₁₆ × 13 ⅝ in.)
Ms. 44 / Ludwig VI 5; 83.MH.88

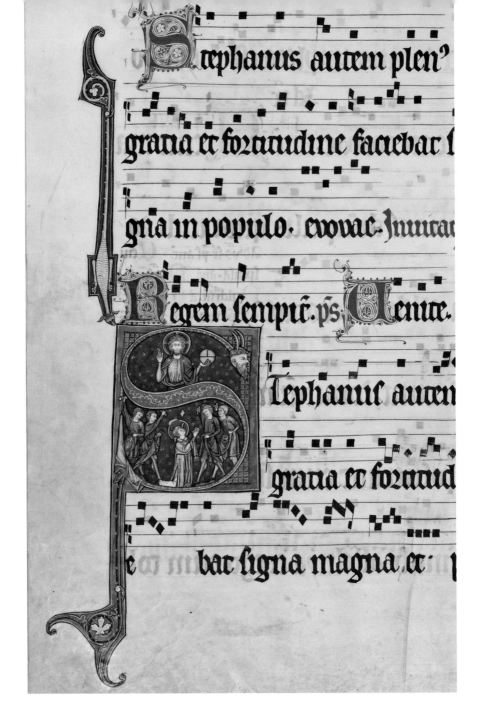

Initial S with The Stoning of Saint Stephen

Leaf 6v (p. 77) from an antiphonal (detail)

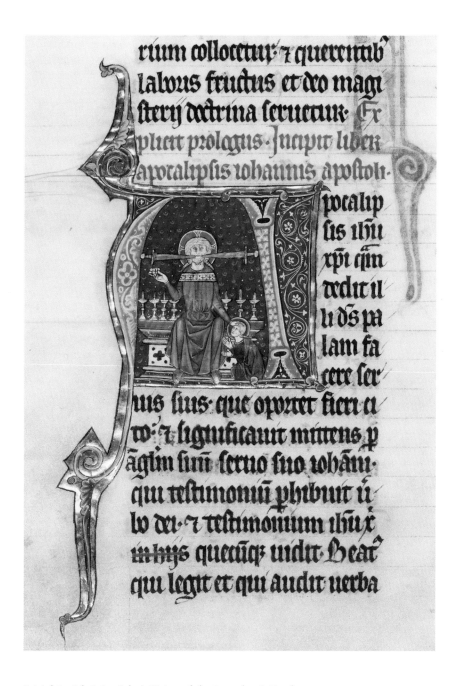

rium collocetur · ⁊ querentib' labous fructus et deo magi stery dcctrina serueur · Ex plicit prologus · Incipit liber apocalipsis iohannis apostoli · pocalip sis ihu xpi qm dedit il li ds pa lam fa cere ser uus sius · que opoztet fieri ci to · ⁊ significauit mittens p agln suu seruo suo iohani qui testimoniu phibuit ú lo dei · ⁊ testimonium ihu xpi in hijs quecuqз uidit. Beat' qui legit et qui audit uerba

Initial A with Saint John's Vision of the Apocalyptic Lord

Final volume of a Bible (incomplete),
fol. 35v
Tournai, Arras, or Lille, ca. 1260–70
Leaf. 46.7 × 35 cm (18 ⅜ × 13 ¾ in.)
Ms. Ludwig I 9; 83.MA.58

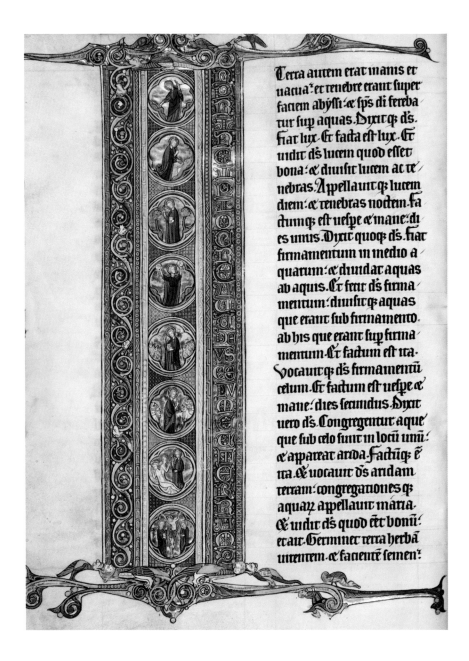

Initial I with The Creation of the World

*Marquette Bible, vol. 1, fol. 10v
and detail*
Probably Lille, ca. 1270
Leaf: 47 × 32.2 cm (18½ × 12 ¹¹/₁₆ in.)
Ms. Ludwig I 8; 83.MA.57

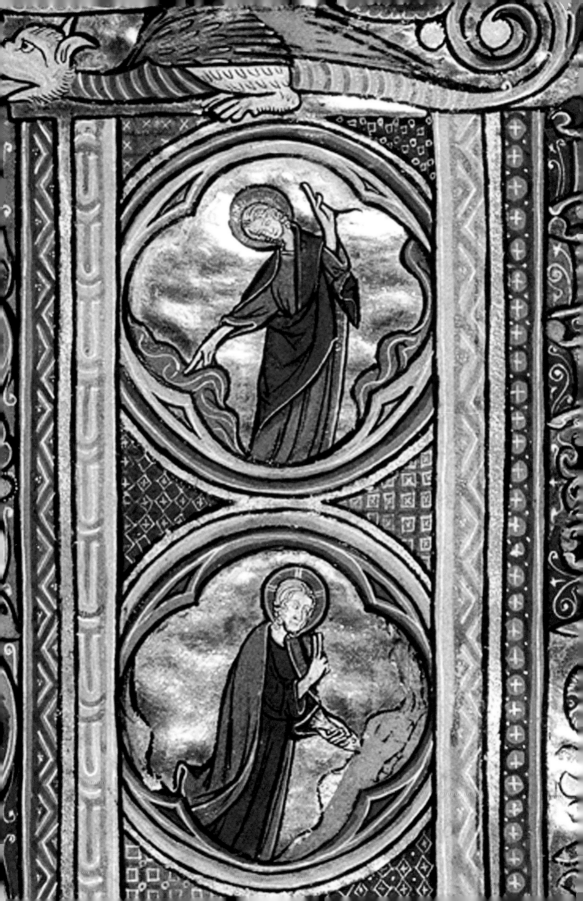

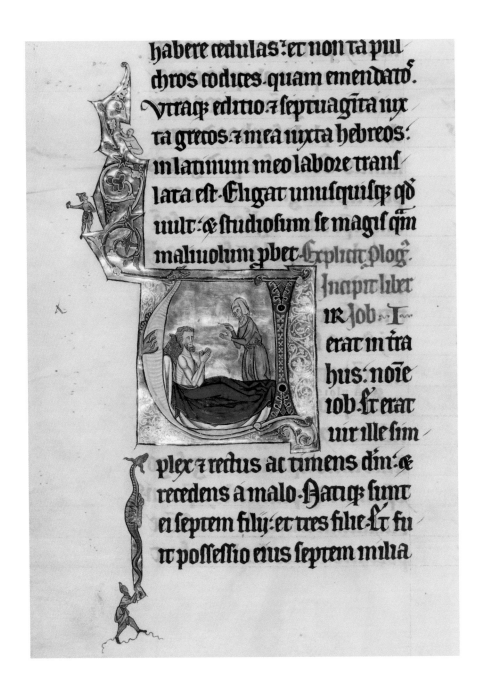

habere cedulas: et non ta pul
chros codices. quam emendatos.
Vtracp editio 7 septuagita iux
ta grecos. 7 mea iuxta hebreos:
in latinum meo labore trans
lata est. Eligat unusquisq qd
uult: & studiosum se magis qm
maliuolum pbet. Explicit plog.
Incipit liber
ir Job. E
erat in tra
hus: noīe
iob. et erat
uir ille sim
plex 7 rectus ac timens dm: &
recedens a malo. Natiq sunt
ei septem filij: et tres filie. Et fu
it possessio eius septem milia

Initial V with Job and His Wife

Marquette Bible, vol. 3, fol. 238v (detail)

Initial I with Esther and Ahasuerus; The Hanging of Haman;
and The Beheading of Two Courtiers

Marquette Bible, vol. 3, fol. 248v (detail)

Initial I with The Reconstruction of Jerusalem

Marquette Bible, vol. 3, fol. 256v (detail)

Bute Master | Initial E with David Playing the Harp

Bute Psalter, fol. 61v
Northeastern France, ca. 1270–80
Leaf: 16.9 × 11.9 cm (6 ¹¹/₁₆ × 4 ¹¹/₁₆ in.)
Ms. 46; 92.MK.92

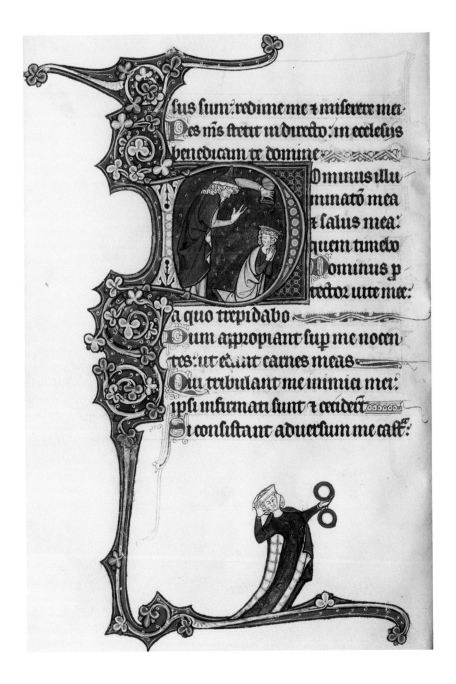

Bute Master | Initial D with The Anointing of David

Bute Psalter, fol. 32v and detail
Northeastern France, ca. 1270 – 80

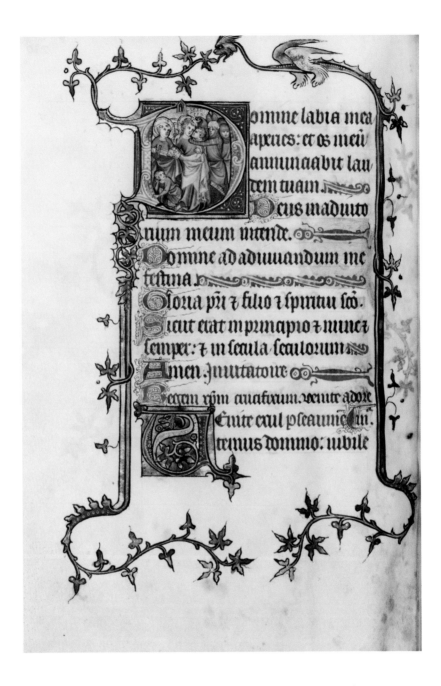

Artist D of the Paris Bible Moralisée | Initial D with The Capture of Christ

Bute Psalter, fol. 280v
Paris, third quarter of the
fourteenth century

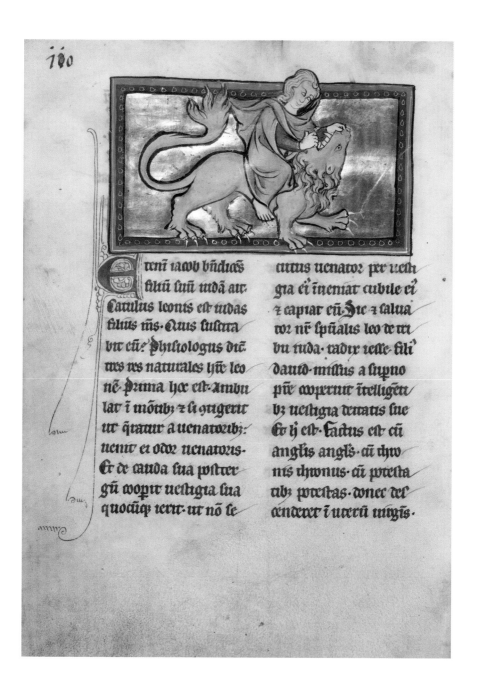

Samson and the Lion

Hugh of Fouilloy, *Aviarium* and *Tractatus de pastoribus et ovibus;*
excerpts from a bestiary; *Mirabilia mundi* (*The Wonders of the World*);
William of Conches, *Philosophia*, (so-called *Bestiary of Duke
Humphrey of Gloucester*), fol. *110v*
Northwestern France, ca. 1277
Leaf: 23.3 × 16.3 cm (9 3/16 × 6 7/16 in.)
Ms. Ludwig XV 4; 83.MR.174

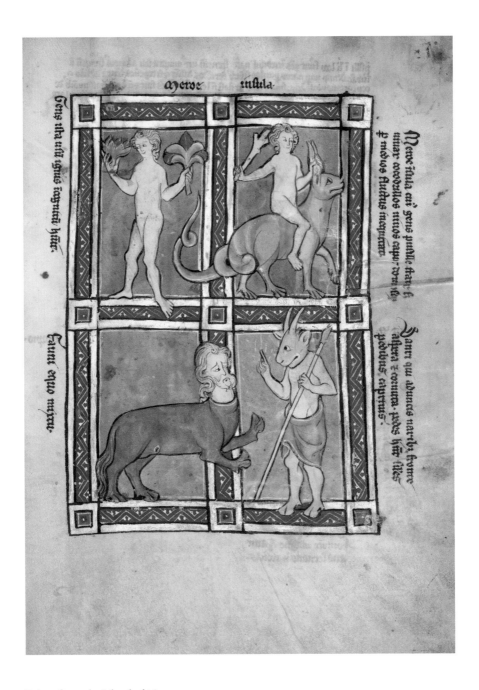

Beings from the Island of Meroe

Hugh of Fouilloy, *Aviarium* and *Tractatus de pastoribus et ovibus;*
excerpts from a bestiary; *Mirabilia mundi* (*The Wonders of the World*);
William of Conches, *Philosophia* (*so-called Bestiary of Duke
Humphrey of Gloucester*), fol. 119

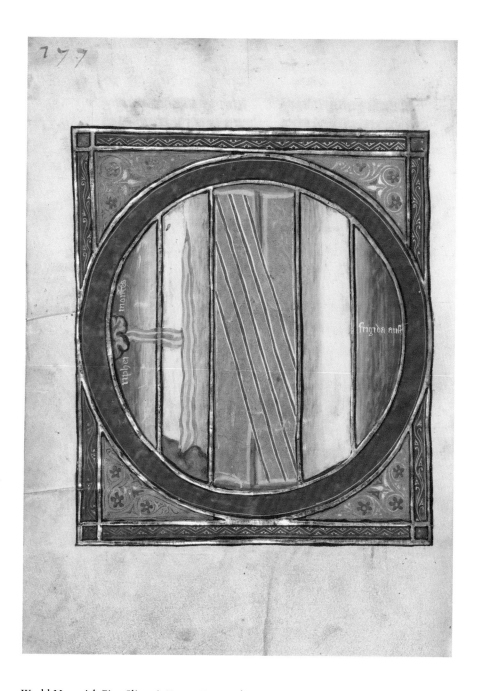

World Map with Five Climatic Zones, East at the Top

Hugh of Fouilloy, *Aviarium* and *Tractatus de pastoribus et ovibus;*
excerpts from a bestiary; *Mirabilia mundi* (*The Wonders of the World*);
William of Conches, *Philosophia* (so-called *Bestiary of Duke
Humphrey of Gloucester*), fol. 117v

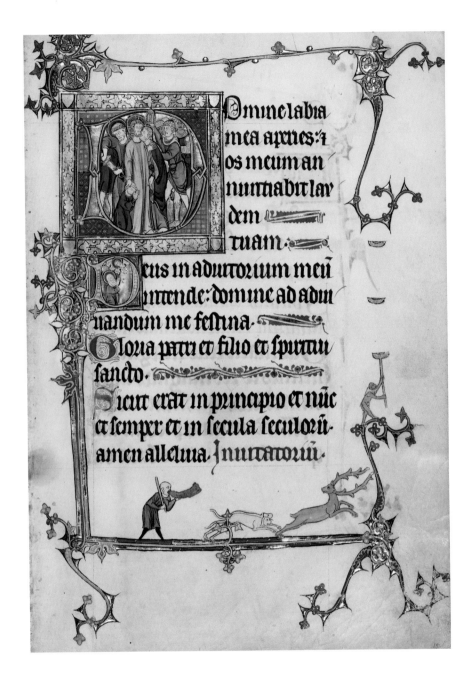

Initial D with The Betrayal of Christ

Ruskin Hours, fol. 15 and detail
Northeastern France, ca. 1300
Leaf: 26.4 × 18.4 cm (10 ⅛ × 7 ¼ in.)
Ms. Ludwig IX 3; 83.ML.99

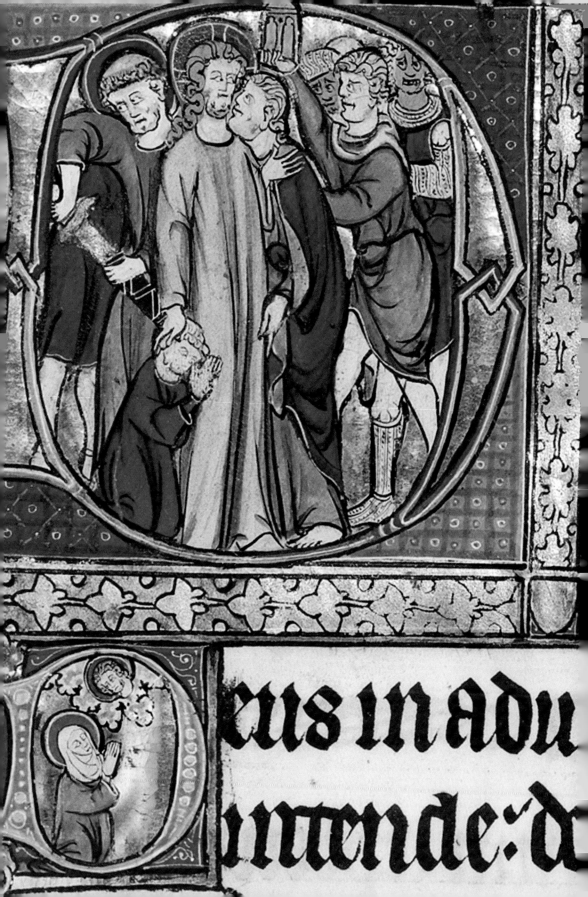

eus in adu
ntende: d

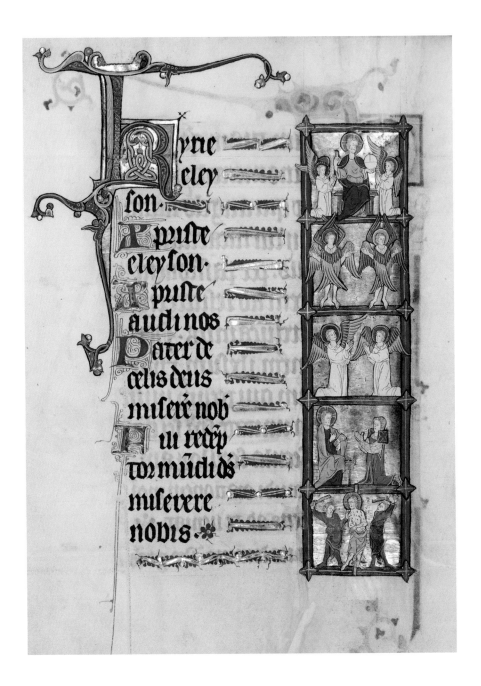

Illuminated Litany

Ruskin Hours, fol. 102v

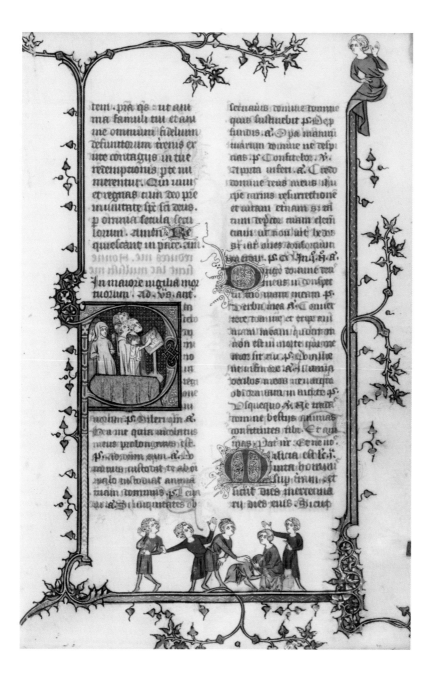

Mahiet? | Initial P with The Office of the Dead (with children's game, possibly blindman's bluff, in bas-de-page)

Winter volume of breviary, use of Châlons-sur-Marne, fol. 99 and detail on following pages
Paris, ca. 1320–25
Leaf: 16.6 × 11.1 cm (6 ⁹⁄₁₆ × 4 ⅛ in.)
Ms. Ludwig IX 2; 83.ML.98

odiem eum . a . do

is custodit te ab oi

e custodiat aia̅m

u dn̅s. ps. Leua

S lin̅quitates ob

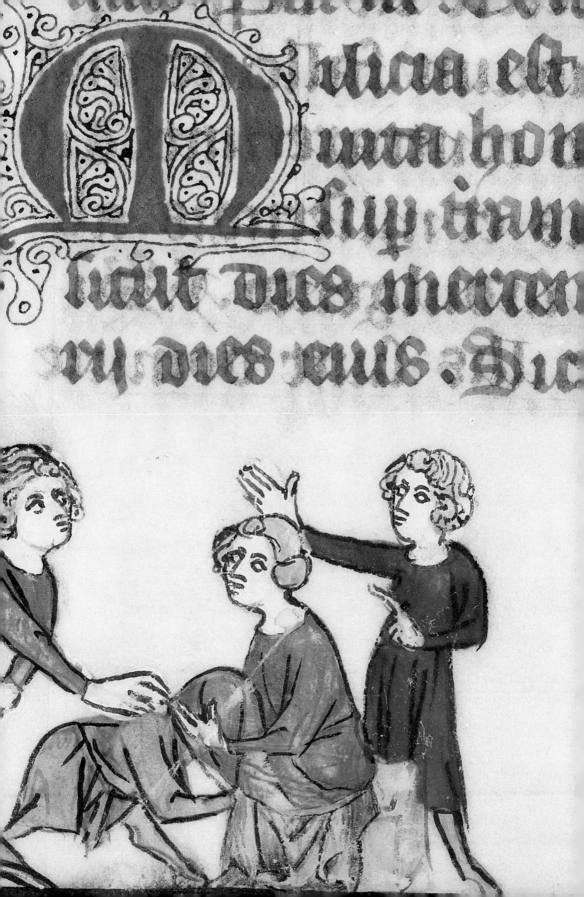

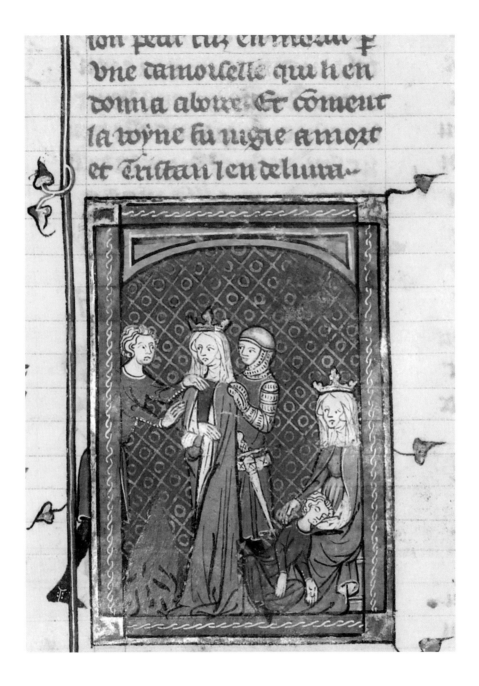

Tristan's Stepmother

*Roman du bon Chevalier Tristan, fils
au bon roy Meliadus de Léonois, fol. 37*
Paris, ca. 1320–40
Leaf: 39.3 × 29.8 cm (15 ½ × 11 ¼ in.)
Ms. Ludwig XV 5; 83.MR.175

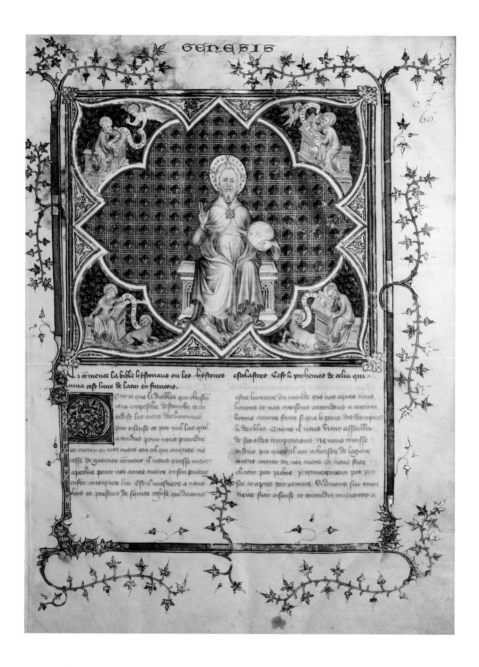

Master of Jean de Mandeville | Christian in Majesty with the Four Evangelists

Guiart des Moulins, *Bible historiale,*
vol. 1, fol. 1
Paris, ca. 1360–70
Leaf: 35 × 26 cm (13 ¹³⁄₁₆ × 10 ¼ in.)
Ms. 1; 84.MA.40

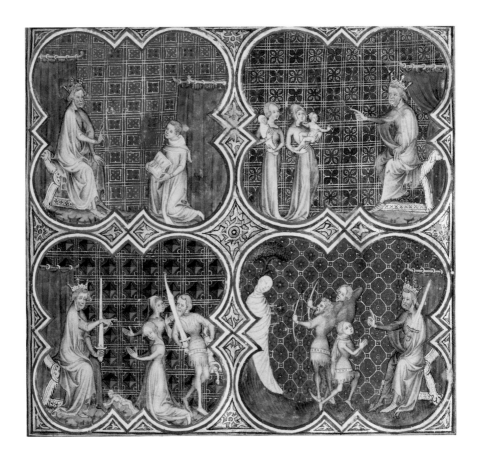

Master of Jean de Mandeville | Scenes from the Book of Solomon

Guiart des Moulins, *Bible historiale,*
vol. 2, fol. 1

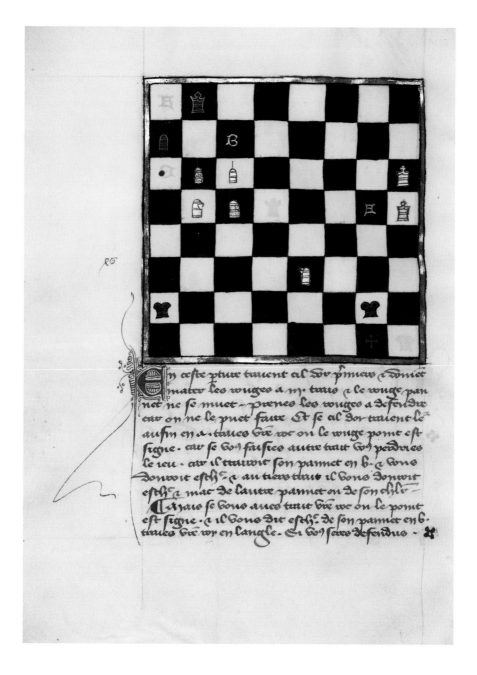

Chess Play

Bonus Socius (*Instruction Book on Chess*), *fol. 30v*
Northern France, end of the fourteenth century
Leaf: 24.8 × 16.8 cm (9 ¼ × 6 ⅞ in.)
Ms. Ludwig XV 15; 83.MR.185

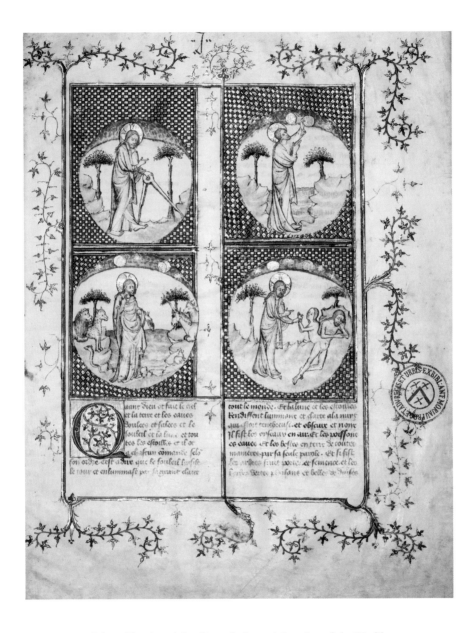

First Master of the Bible Historiale of Jean de Berry | Creation of the World

*Leaf 1 from the Histoire ancienne
jusqu'à César*
Probably Paris, ca. 1390–1400
Leaf: 37.9 × 29.5 cm (14 $^{15}/_{16}$ × 11 $^{5}/_{8}$ in.)
Ms. Ludwig XIII 3; 83.MP.146

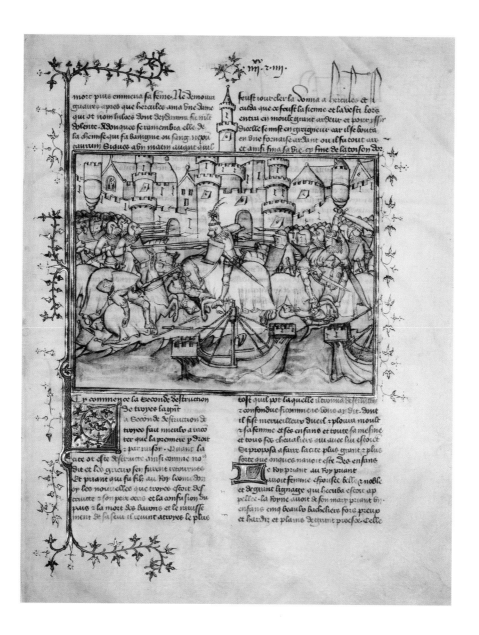

First Master of the Bible Historiale of Jean de Berry | A Battle from the Trojan War

Leaf 3 from the Histoire ancienne
jusqu'à César

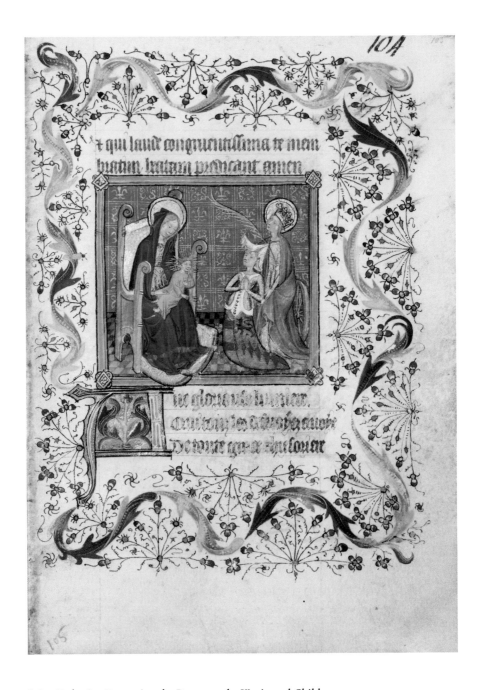

Saint Catherine Presenting the Patron to the Virgin and Child

Book of hours, use of Le Mans, fol. 105
Paris or Le Mans, ca. 1400–1410
Leaf: 18.8 × 13.2 cm (7 ⅜ × 5 ⅛ in.)
Ms. Ludwig IX 4; 83.ML.100

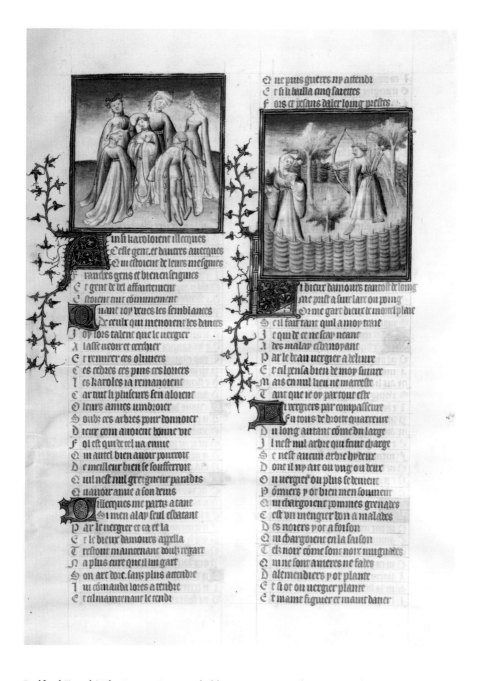

Bedford Trend | The Lovers Surrounded by Dancers; Cupid Aiming at the Lover

Guillaume de Lorris and Jean de Meun,
Roman de la Rose, fol. 10
Paris, ca. 1405
Leaf: 36.7 × 26 cm (14 ½ × 10 ¼ in)
Ms. Ludwig XV 7; 83.MR.177

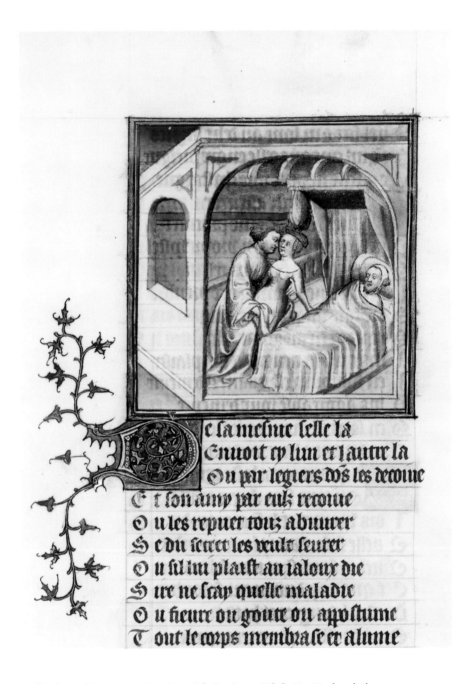

e ſa meſine ſelle la
Enuoit ep lun et l autre la
Ou par legiers dōs les deconie
Et ſon amp par eulz reconie
Ou les repuct touz abuurer
Se du ſecret les veult ſeurer
Ou ſil lui plaiſt au taloux die
Sire ne ſcay quelle maladie
Ou fieure ou goute ou appoſtume
Tout le corps membra ſe et alume

Bedford Trend | **A Woman Meeting with Her Lover While Her Husband Sleeps**

Guillaume de Lorris and Jean de Meun,
Roman de la Rose, fol. 91v (detail)

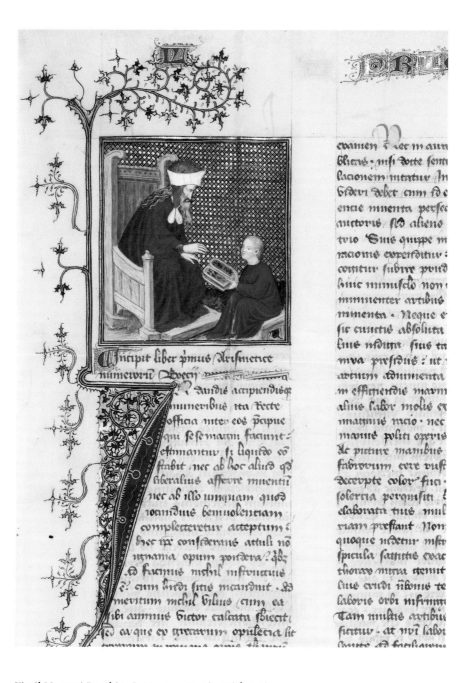

Virgil Master | Boethius Instructs a Boy in Arithmetic

Alchandreus, *Liber Alchandrei
philosophi;* Boethius, *De arithmetica,
De musica,* fol.26
Paris, ca. 1405
Leaf: 39 × 30.5 cm (15 ⅜ × 12 in.)
Ms. 72; 2003.25

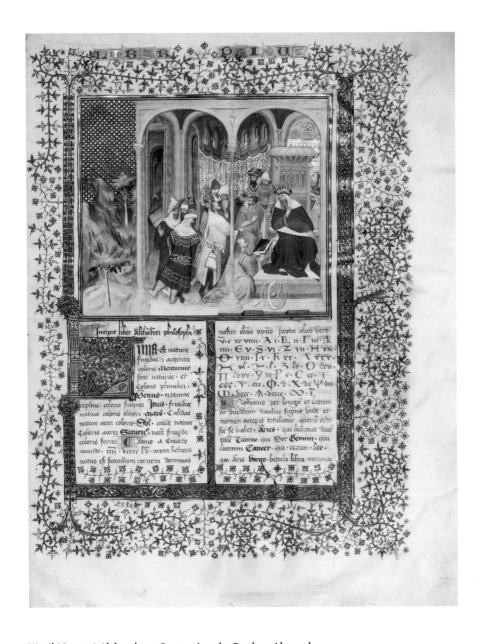

Virgil Master | Alchandreus Presenting the Book to Alexander

Alchandreus, *Liber Alchandrei philosophi;* Boethius, *De arithmetica, De musica,* fol. 2 and detail

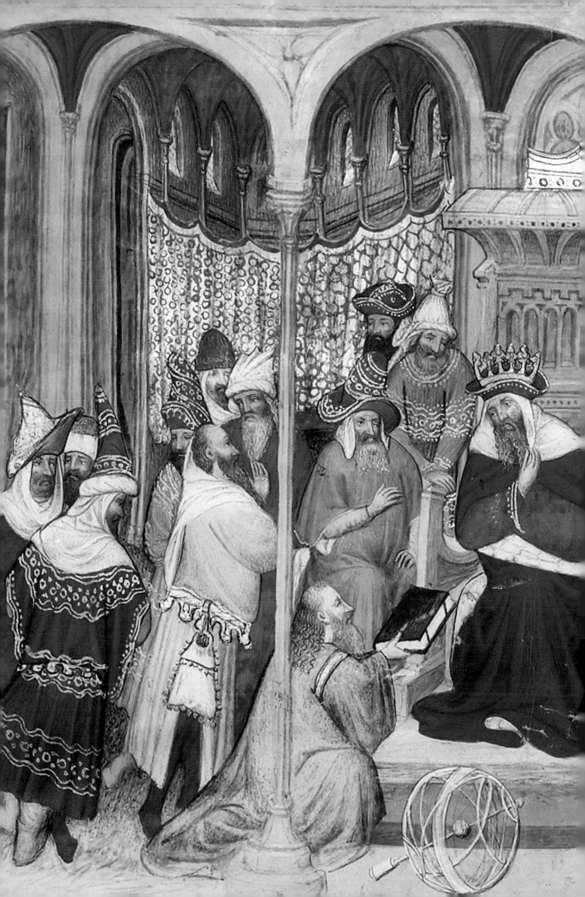

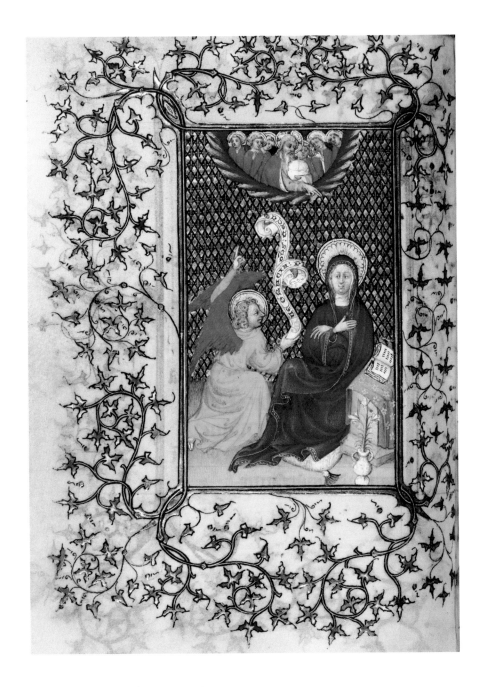

Pseudo-Jacquemart | The Annunciation

Book of hours (incomplete), fol. 25v
Probably Bourges or Paris, ca. 1410
Leaf: 17.8 × 13.3 cm (7 × 5 ¼ in.)
Ms. 36; 89.ML.3

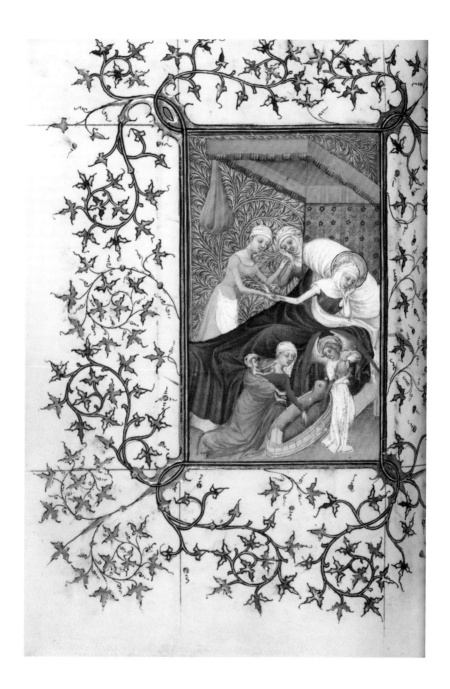

Pseudo-Jacquemart | The Birth of the Virgin

Book of hours (incomplete), fol. 71v

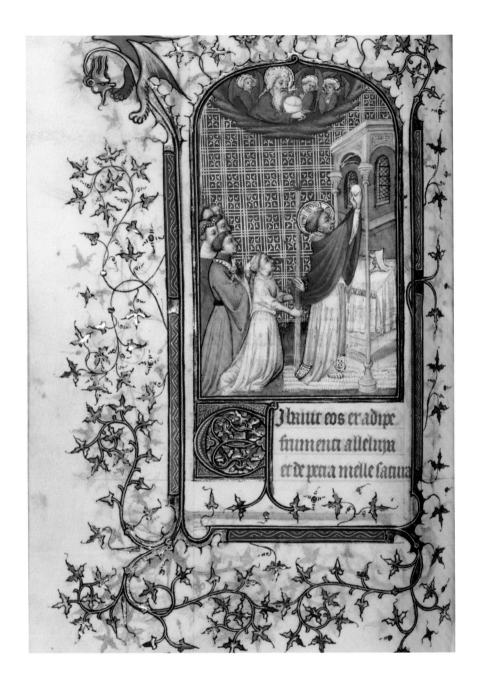

Pseudo-Jacquemart | The Elevation of the Host

Book of hours (incomplete), fol. 53

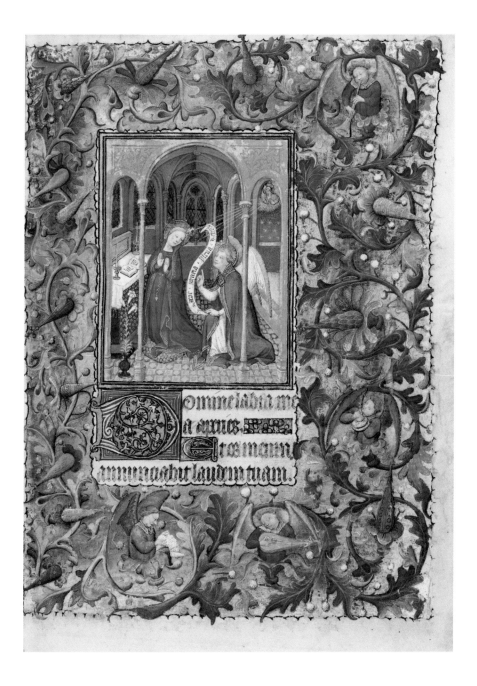

Workshop of the Mazarine Master | The Annunciation

Book of hours, use of Paris, fol. 27
Paris, ca. 1410
Leaf: 19 × 14 cm (7 ½ × 5 ½ in.)
Ms. Ludwig IX 5; 83.ML.101

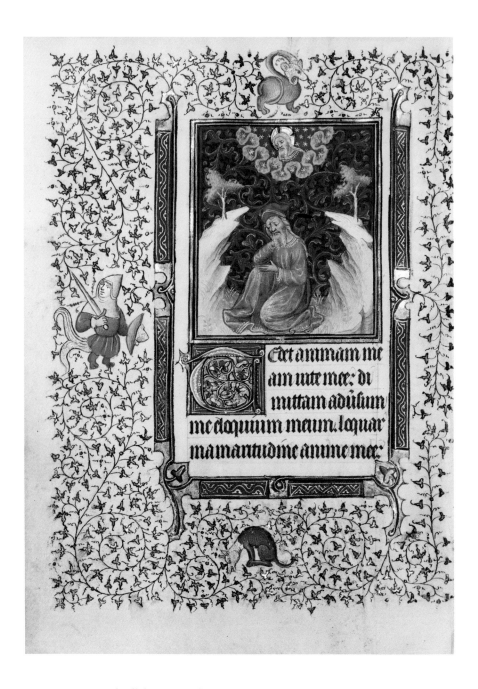

Egerton Master and collaborator | Job Seated

Book of hours, use of Paris, fol. 136v

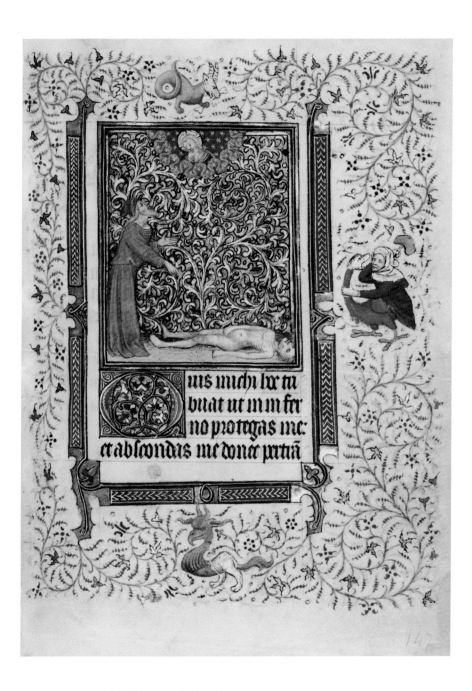

Egerton Master and collaborator | Job and a Corpse

Book of hours, use of Paris, fol. 147

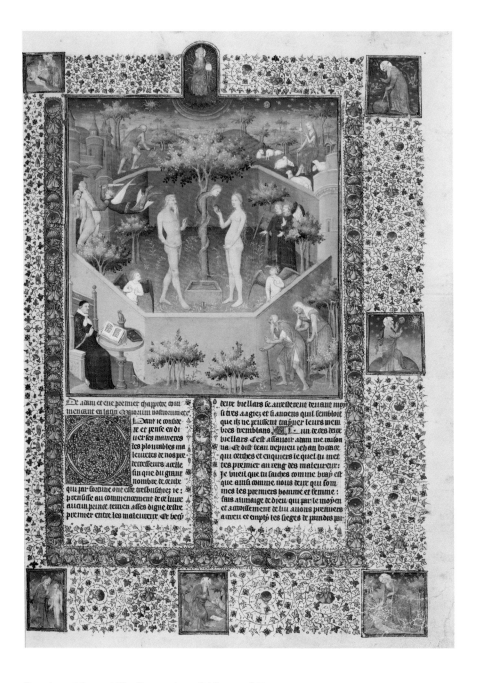

Boucicaut Master | The Temptation of Adam and Eve

Giovanni Boccaccio, *Des cas des nobles hommes et femmes (Concerning the Fates of Illustrious Men and Women)*, fol. 3
Paris, ca. 1415
Leaf: 42 × 29.6 cm (16 9/16 × 11 11/16 in.)
Ms. 63; 96.MR.17

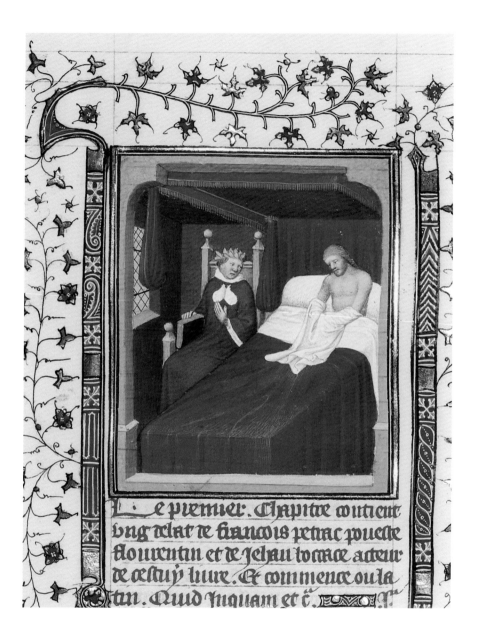

Boucicaut Master | Petrarch at the Bedside of Boccaccio

Giovanni Boccaccio, *Des cas des nobles
hommes et femmes* (*Concerning the Fates
of Illustrious Men and Women*), fol. 243

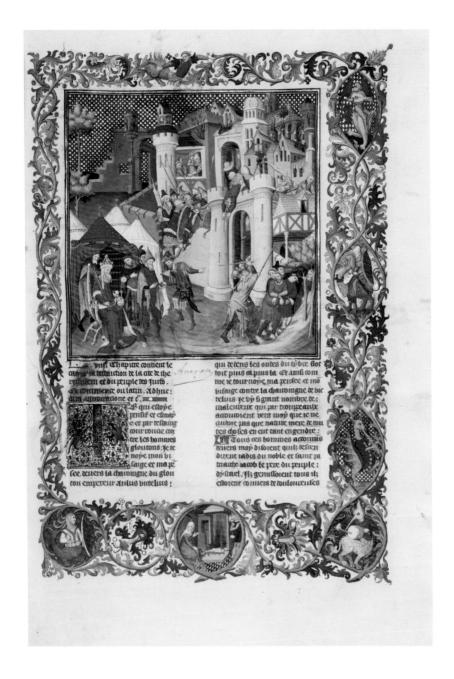

Titus Ordering the Destruction of Jerusalem

Giovanni Boccaccio, *Des cas des nobles hommes et femmes* (*Concerning the Fates of Illustrious Men and Women*), fol. 237 and detail

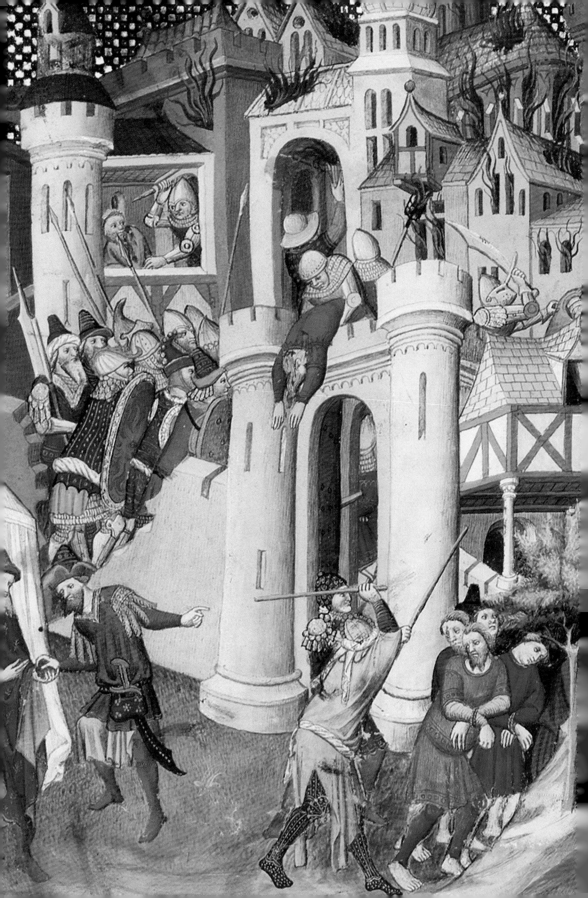

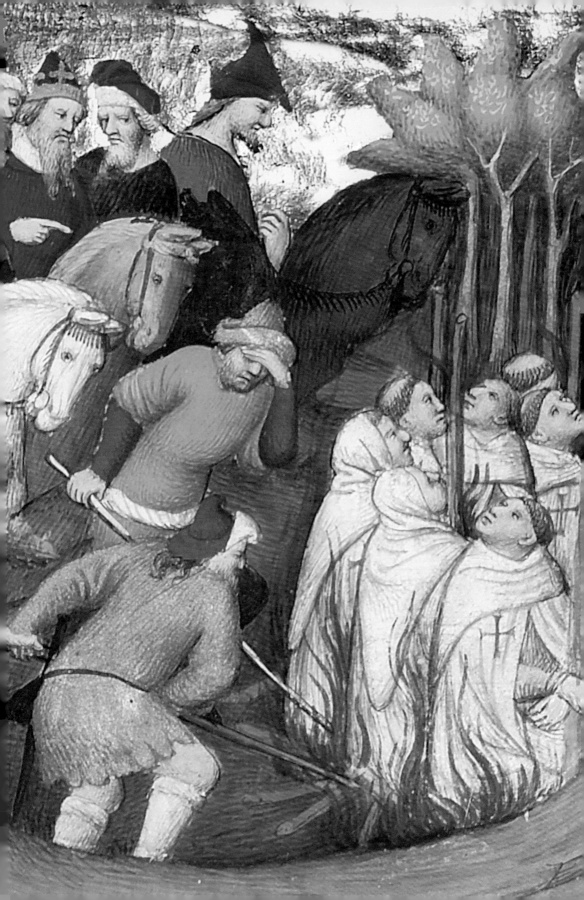

Boucicaut Master | The Knights Templar

Boucicaut Master | All Saints

Book of hours, fol. 257
Paris, ca. 1415–20
Leaf: 20.4 × 14.9 cm (8 × 5⅞ in.)
Ms. 22; 86.ML.571

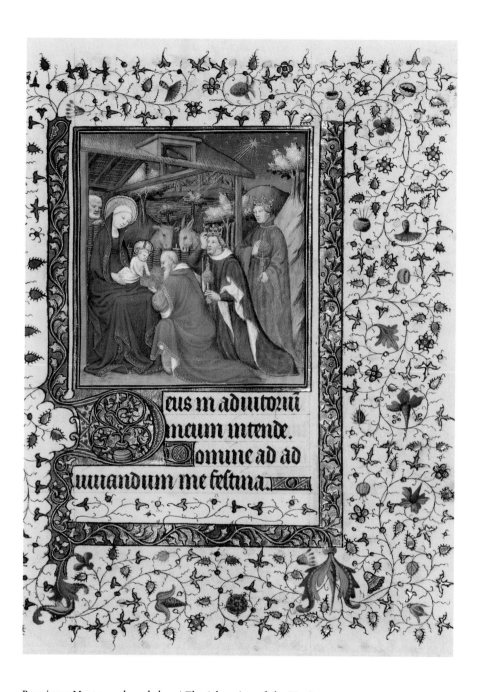

Boucicaut Master and workshop | The Adoration of the Magi

Book of hours, fol. 72

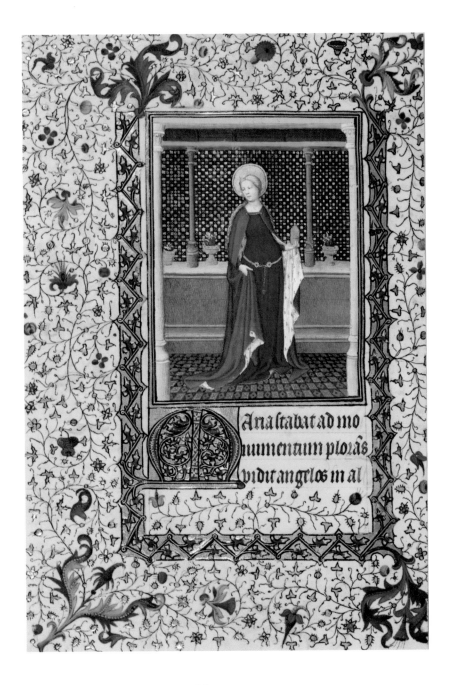

Boucicaut Master | Saint Mary Magdalene

Book of hours, fol. 274v and detail

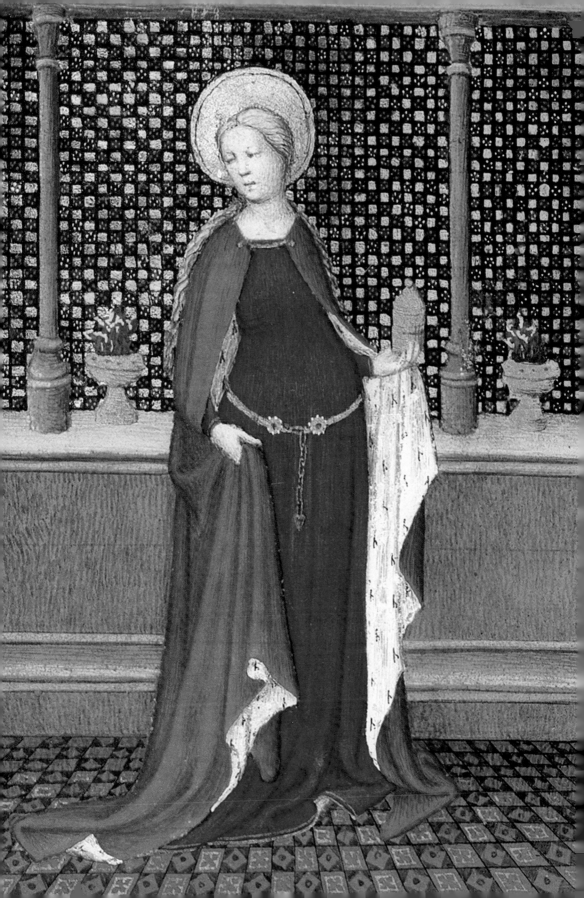

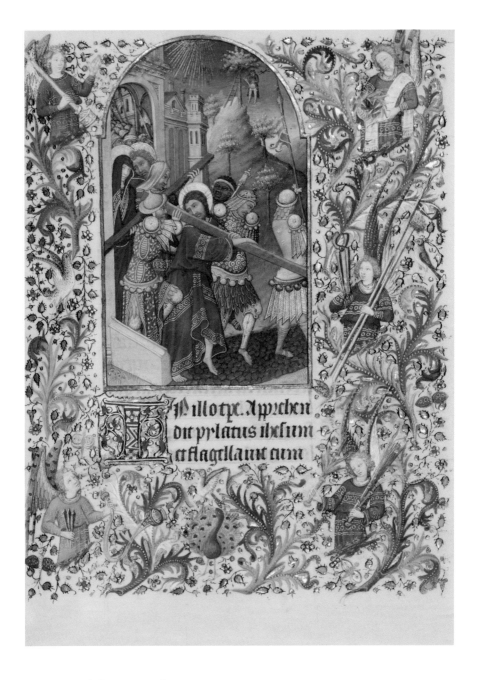

Spitz Master | The Way to Calvary

Book of hours, fol. 31
Paris, ca. 1420
Leaf: 20.1 × 15 cm ($7^{15}/_{16}$ × $5^{7}/_{8}$ in.)
Ms. 57; 94.ML.26

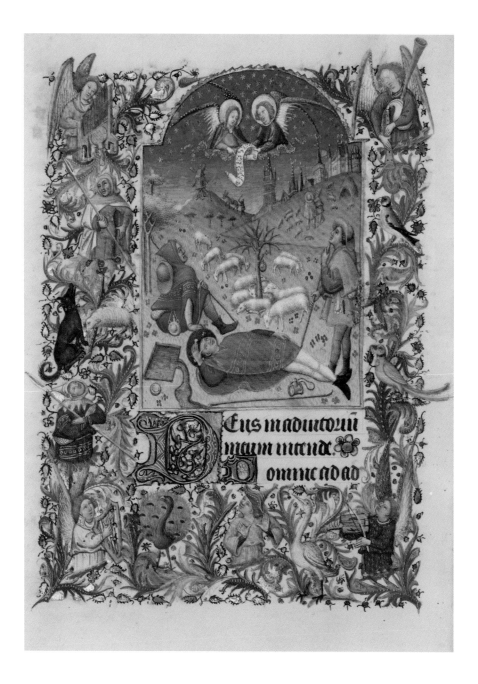

Spitz Master | The Annunciation to the Shepherds

Book of hours, fol. 89v

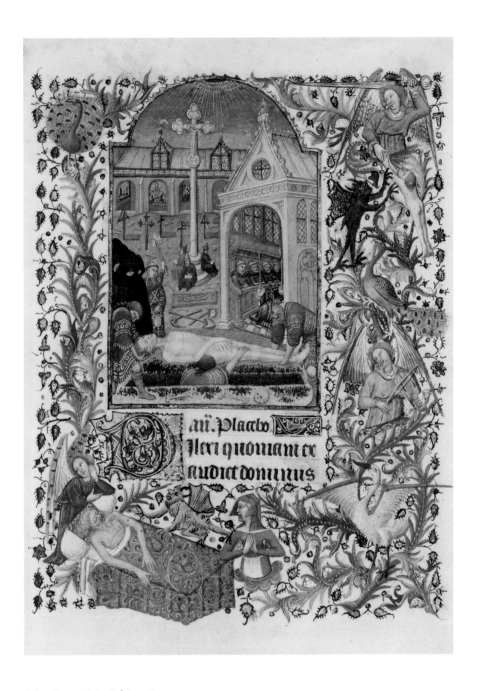

Spitz Master | Burial in a Cemetery

Book of hours, fol. 194 and detail

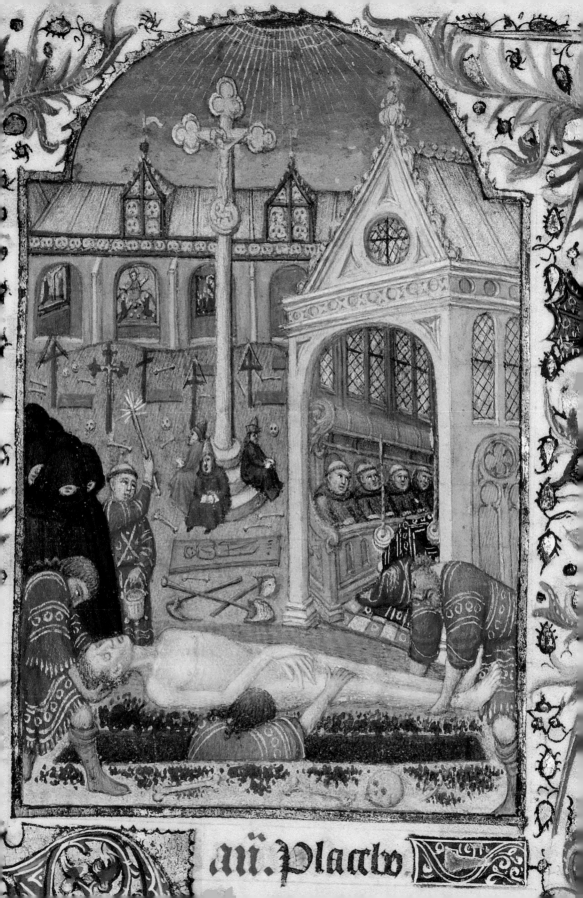

aũ. Placebo

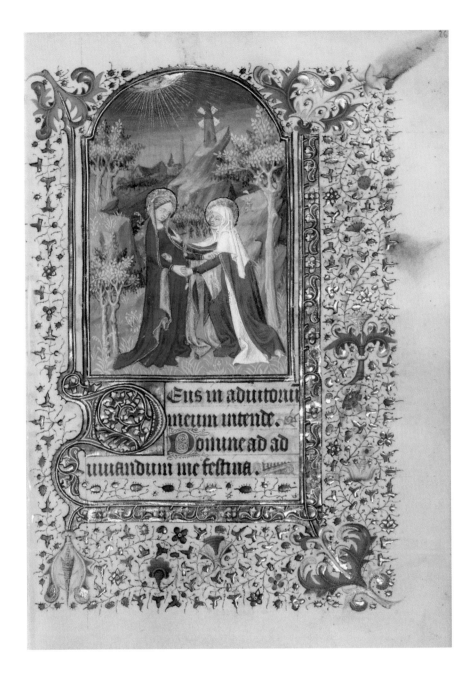

Master of the Harvard Hannibal | The Visitation

Book of hours, use of Paris, fol. 26
France, ca. 1420–30
Leaf: 17.9 × 13 cm (7 ⁷⁄₁₆ × 5 ⅛ in.)
Ms. 19; 86.ML.481

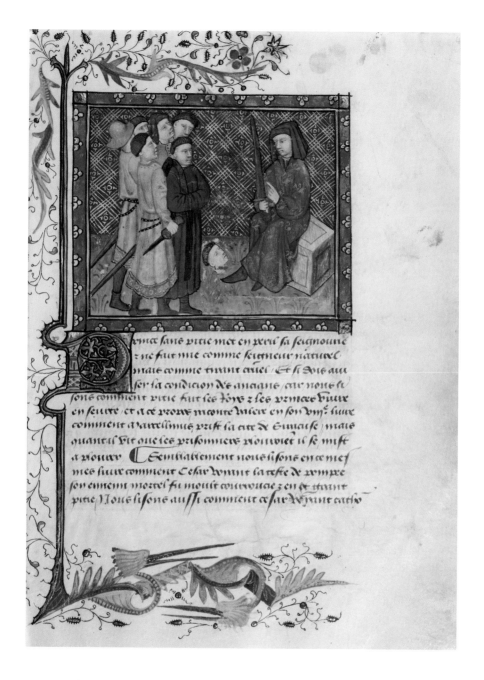

Caesar and the Head of Pompeius

Jacques Legrand, *Livre de bonnes meurs*, fol.41
Probably Avignon, ca. 1430
Leaf: 24.9 × 17.8 cm (9 ¹³/₁₆ × 7 in.)
Ms. Ludwig XIV 9; 83.MQ.170

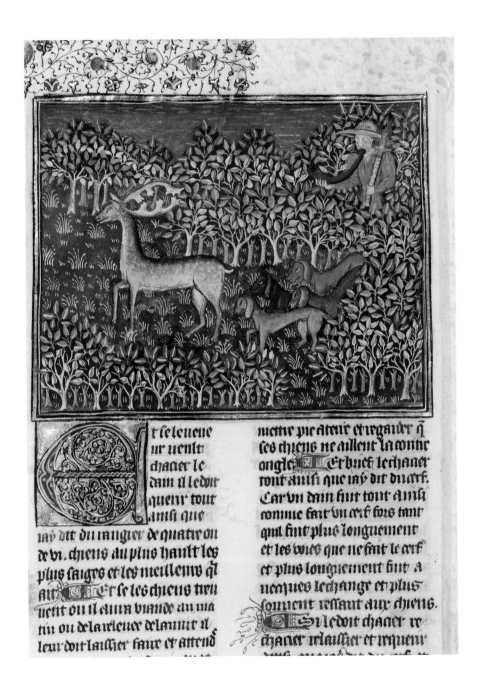

t se leueue
ur ueult
chacier le
dam il le doit
queur tout
amsi que
ias dit du ranguer de quatre ou
de vi. chiens au plus hault les
plus saiges et les meilleurs qil
aut [C] Et se les chiens tru
uent ou il euna viande au ma
tin ou dela uieue delanuit il
leur doit laissier saire et attend

mettre pie atene et regaude q̃
ses chiens ne aillent la contre
ongle [C] Et buef lechacer
tout ainsi que ias dit duarf.
Carun dain huit tout ainsi
comme fait un cerf fors tant
quil huit plus longuement
et les uoies que ne sait le cerf
et plus longuement huit a
nensues lechange et plus
souuent restaut aux chiens.
[C] Si le doit chacer re
chacier relaissier et requeur

Hunter and Dogs Pursuing Fallow Deer

Gaston Phébus, *Livre de la chasse,*
fol. 81v *(detail)*
Brittany (?), ca. 1430–40
Leaf: 26.3 × 18.4 cm (10⅜ × 7¼ in.)
Ms. 27; 87.MR.34

tr que ien fay et pourr dirap aucturs. Come on doit mettre
comment atraur des arts ou les bestes au tour pour traire. lxxi
prent les bestes sans chaser
aurtheus cest mettre les des

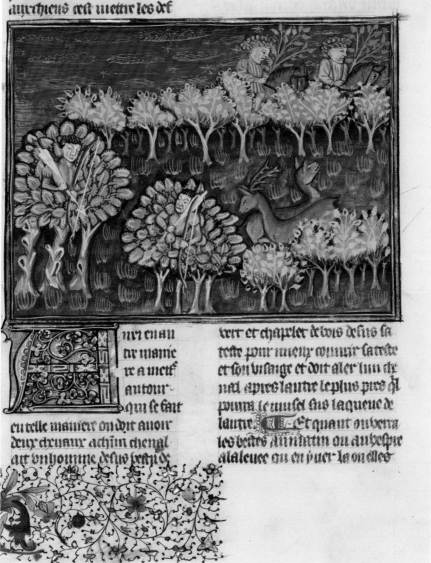

ur en au
tir mame
re a metr
autour
qui se fait
en telle maniere on doit auoir
deux druaux achun chenal
ait vnhomme desus sextpus

tert et chaplet de bois desus sa
teste pour mienlx couurir sa teste
et son visaige et doit aler lun che
nal apres lautre leplus pres q̃l
pourra le ungfel sus laqueue de
lautre. Et quant onuenra
les bestes al matin ou aubespre
alaleuee ou en yuer la ou elles

Camouflaged Hunters Preparing to Attack Deer

Gaston Phébus, *Livre de la chasse,*
fol. *109* (*detail*)

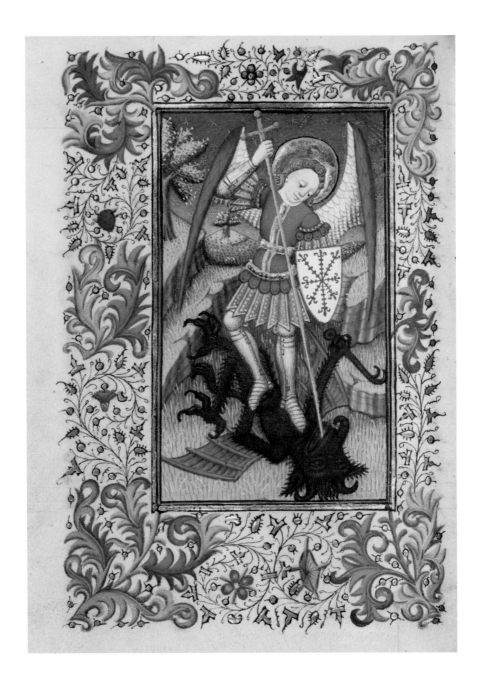

Master of Sir John Fastolf | Saint Michael and the Dragon

Book of hours, use of Sarum, fol. 19v
France (probably Rouen) or
England, ca. 1430–40
Leaf: 12 × 9.2 cm (4 ¼ × 3 ⅝ in.)
Ms. 5; 84.ML.723

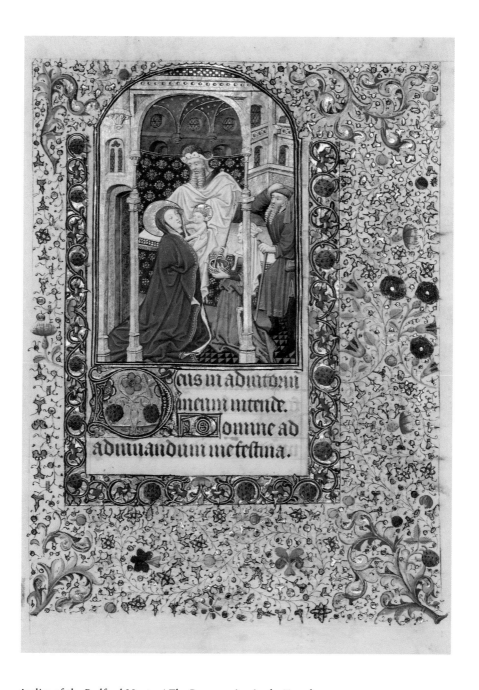

Atelier of the Bedford Master | The Presentation in the Temple

Book of hours, use of Paris, fol. 83
Paris, ca. 1440–50
Leaf: 23.5 × 16.3 cm (9¼ × 6⁷⁄₁₀ in.)
Ms. Ludwig IX 6; 83.ML.102

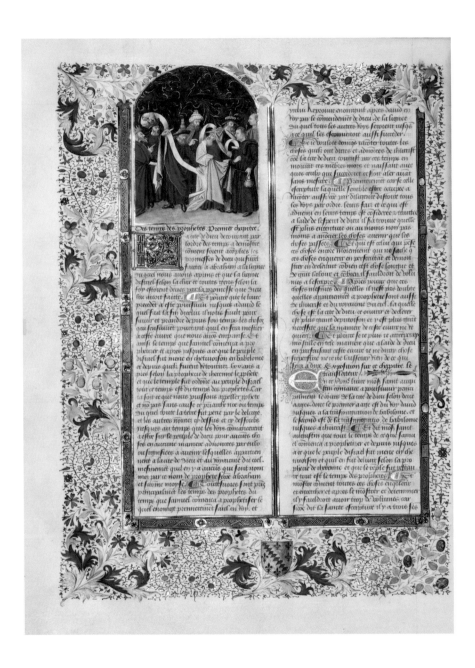

Attributed to the Master of the Geneva Boccaccio | Philosophical Disputation

St. Augustine, *Cité de Dieu*, translation
and commentary by Raoul de Presles,
fol. 115v and detail
Angers, ca. 1440–50
Leaf: 36.2 × 27.3 cm (14¼ × 10¹¹⁄₁₆ in.)
Ms. Ludwig XI 10; 83.MN.129

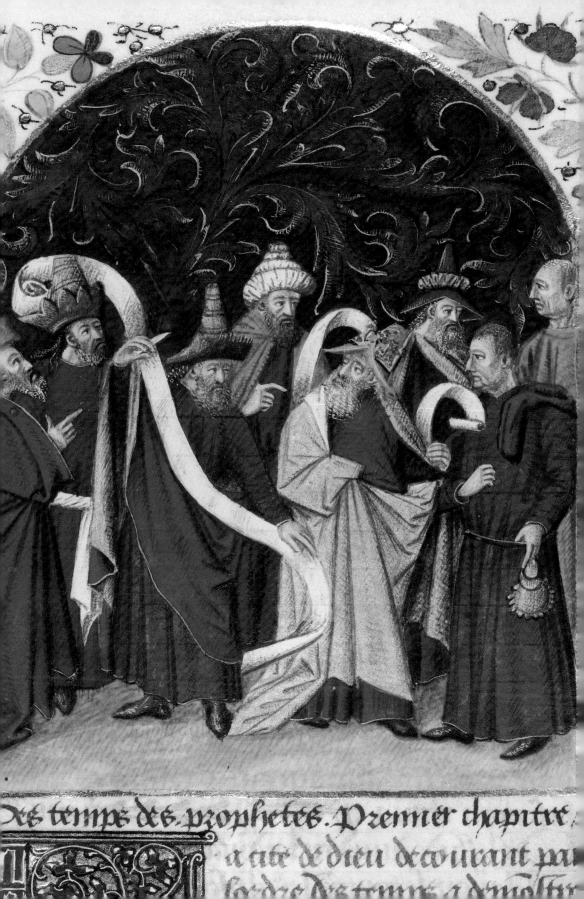

es temps des prophetes. Premier chapitre

a cité de dieu decourant par
lordre des temps z demostr

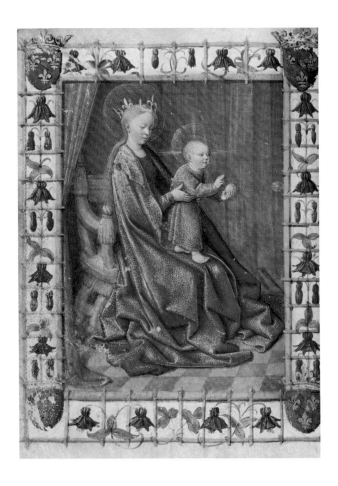

Jean Fouquet | Simon de Varie in Prayer before the Virgin and Child

Hours of Simon de Varie, fols. 1v–2
Tours and perhaps Paris, 1455
Leaf: 11.5 × 8.2 cm (4 ⁹⁄₁₆ × 3 ¼ in.)
Ms. 7; 85.ML.27

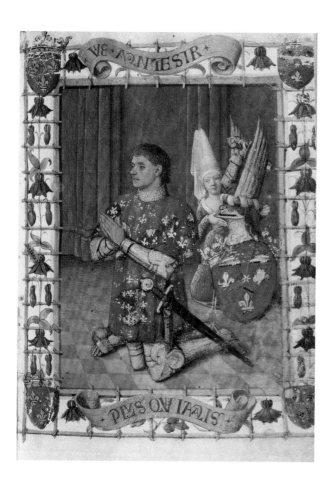

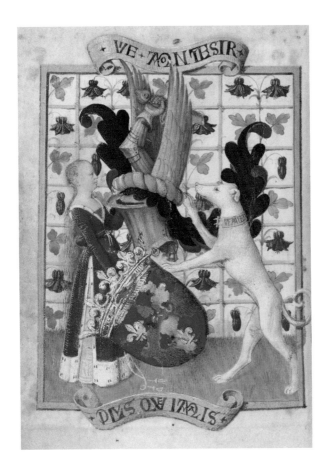

Jean Fouquet | Woman and Dog Supporting Varie Armorials

Hours of Simon de Varie, fol. 2v

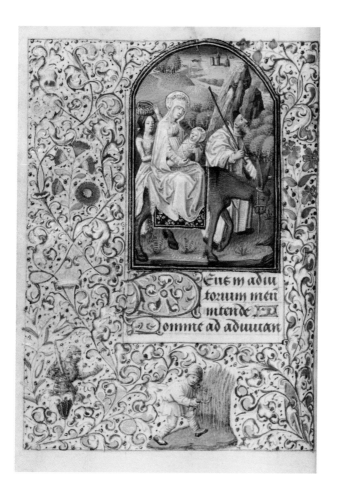

Master of Jean Rolin II | The Flight into Egypt

Hours of Simon de Varie, fol. 28v

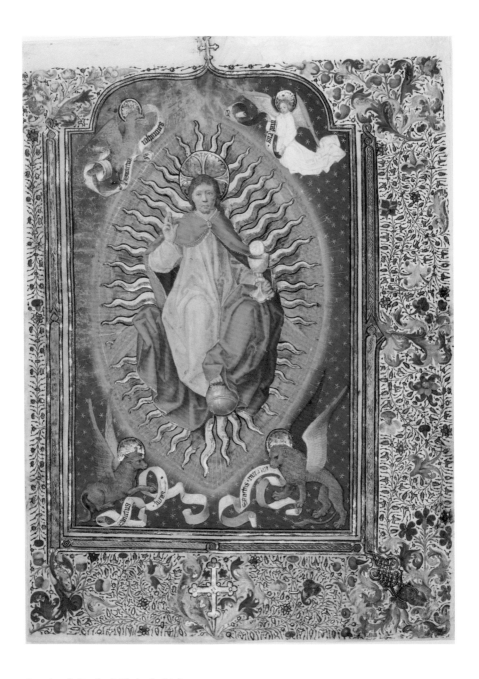

Antoine de Lonhy | **Christ in Majesty**

Leaf from a missal
Toulouse, ca. 1460
Leaf: 34.5 × 25 cm (13 ⅝ × 9 ⁷⁄₁₆ in.)
Ms. 69; 2001.84
Gift from the Emerson Family in
honor of John S. Bonnell

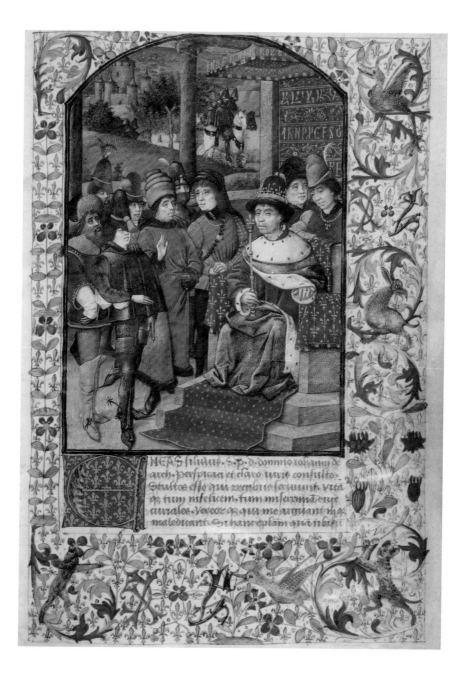

The King of France Receives a Courtier

Aeneas Silvius Piccolomini,
*Historia de duobus amantibus
and other writings, fol. 1*
France, ca. 1460–70
Leaf: 17.4 × 11.7 cm (6⅞ × 4⅝ in.)
Ms. 68; 2001.45

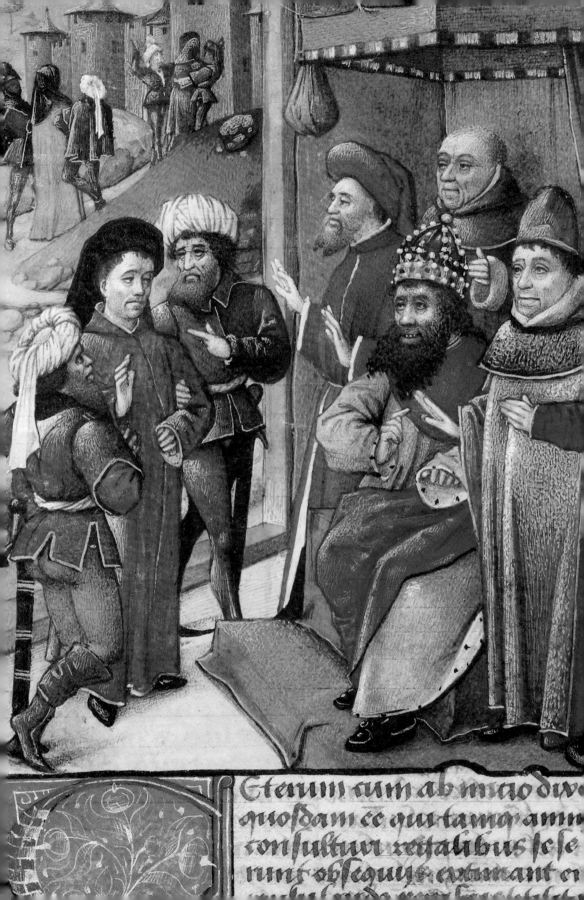

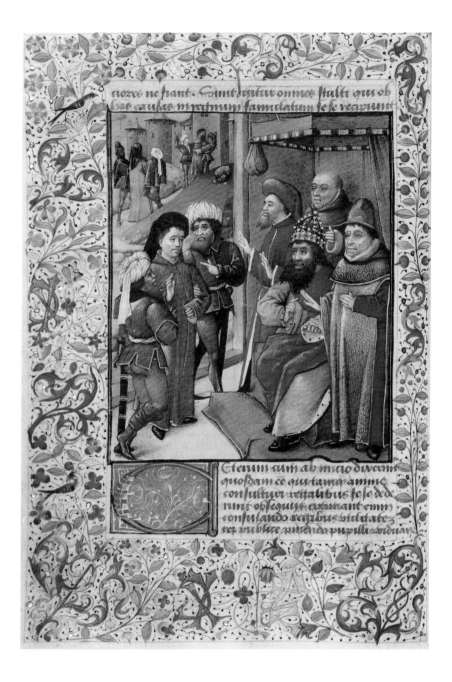

The Holy Roman Emperor Receives a Prisoner

Aeneas Silvius Piccolomini,
Historia de duobus amantibus
and other writings, fol.14v
and detail

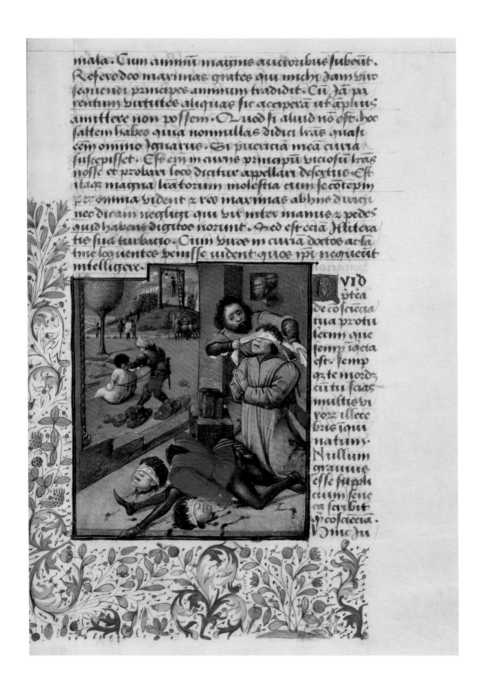

A Massacre of Family Members

Aeneas Silvius Piccolomini,
Historia de duobus amantibus
and other writings, fol. 23

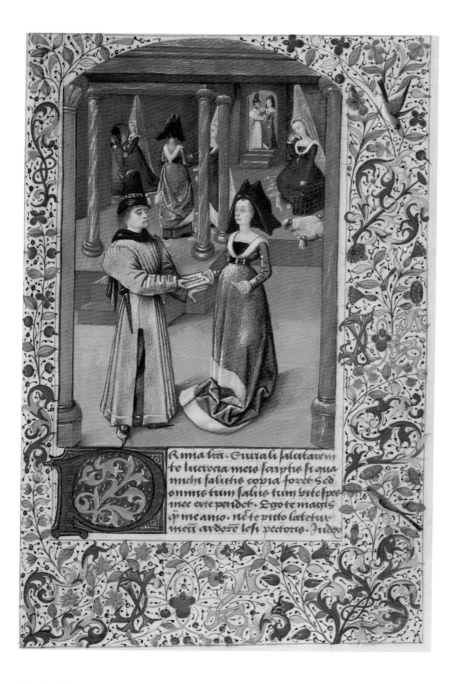

Euralyus's Letter to Lucretia

Aeneas Silvius Piccolomini,
*Historia de duobus amantibus
and other writings, fol. 30*

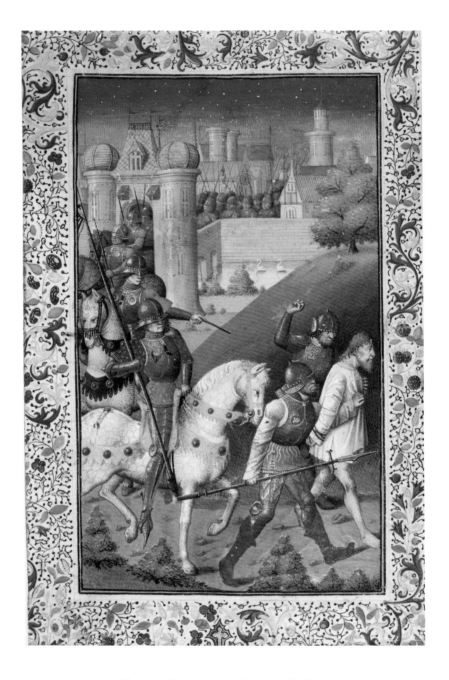

Maitre François | Soldiers Leading a Prisoner from a Walled City

Detached leaf
Paris, ca. 1460–70
Leaf: 18 × 12 cm ($7\frac{1}{8}$ × $4\frac{1}{4}$ in.)
Ms. 51; 93.MS.31

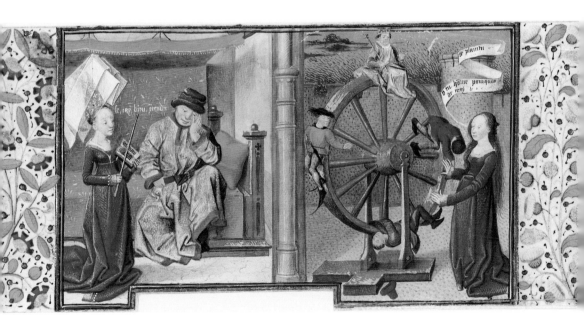

Coëtivy Master | Philosophy Consoling Boethius; Fortune Turning the Wheel

Leaf 1 from three miniatures and
border fragments from Boethius,
La Consolation de philosophie
Paris, ca. 1460–70
Leaf: 7.4 × 16.9 cm (2⅞ × 6¹¹⁄₁₆ in.)
Ms. 42; 91.MS.11.1

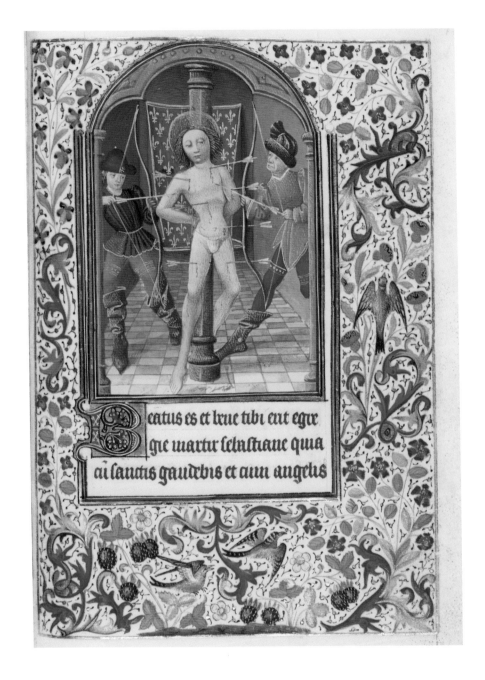

Master of Jacques of Luxembourg | The Martyrdom of Saint Sebastian

Hours of Jacques of Luxembourg,
use of Poitiers, fol. 126
North France, Hennegau, or Bruges,
ca. 1466–70
Leaf: 16.3 × 11.4 cm (6⁷⁄₁₀ × 4½ in.)
Ms. Ludwig IX 11; 83.ML.107

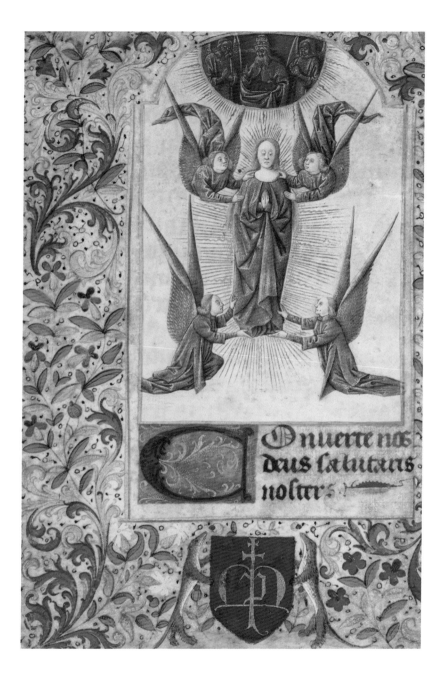

Master of Jean Charpentier | The Assumption of the Virgin

Leaf from a book of hours
Tours, early 1470s
Leaf: 17 × 11.6 cm (6 ¹¹⁄₁₆ × 4 ⁹⁄₁₆ in.)
Ms. 21; 86.ML.537

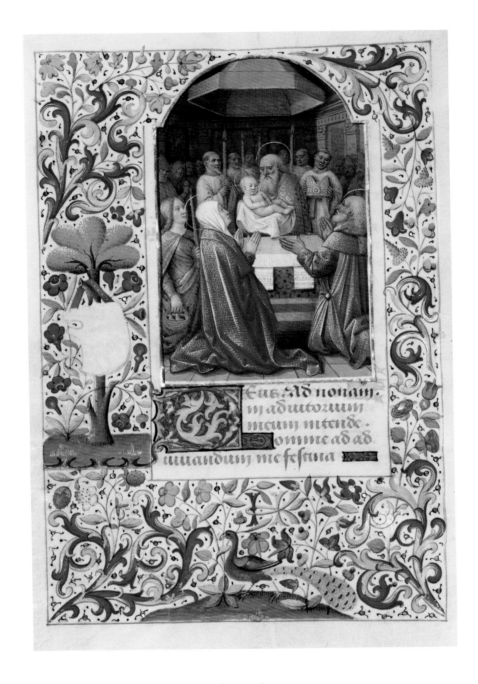

Jean Bourdichon | The Presentation in the Temple

Katherine Hours, fol. 62v
Tours, ca. 1480–85
Leaf: 16.3 × 11.6 cm (6 7/16 × 4 9/16 in.)
Ms. 6; 84.ML.746

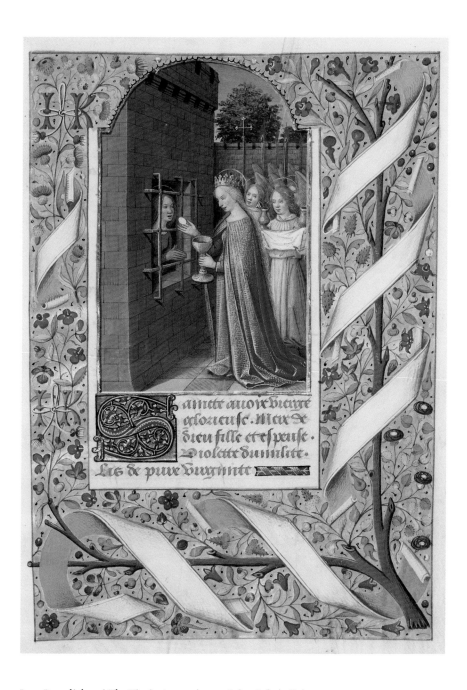

Jean Bourdichon | The Virgin Appearing to Saint Avia in Prison

Katherine Hours, fol. 143

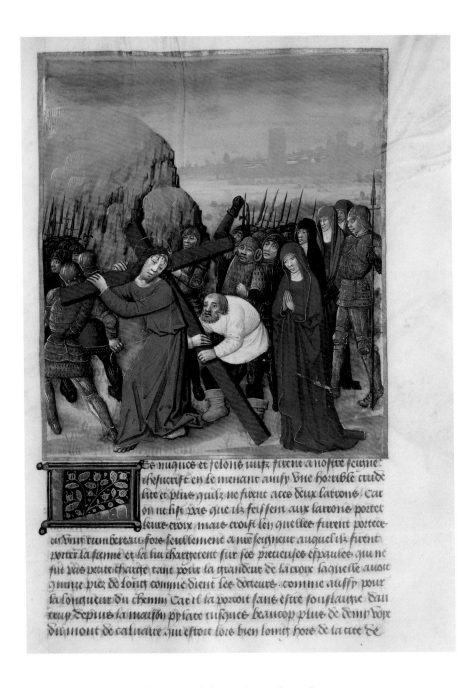

Master of Guillaume Lambert or workshop | The Road to Calvary

Attributed to Jean Gerson, *La Passion de Nostre Seigneur Ihesus Christ;
La Vengeance de Nostre Sauveur, fol. 38*
Lyons, ca. 1480–90
Leaf: 30.4 × 21.6 cm (12 × 8 ½ in.)
Ms. 25; 86.MN.730

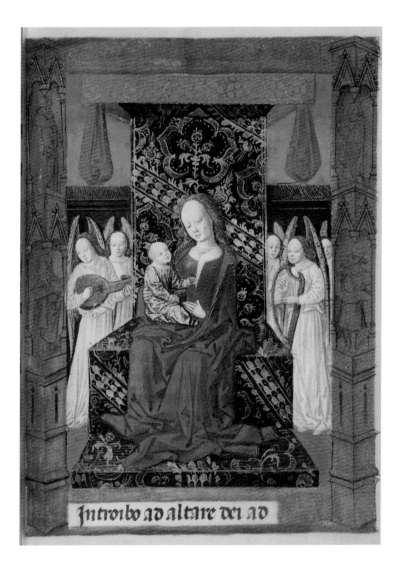

Master of Guillaume Lambert | Madonna and Child with Musical Angels

Book of hours, use of Rome, fol. 21
Lyons, 1478
Leaf: 14.6 × 9.8 cm (5¼ × 3⅞ in.)
Ms. 10; 85.ML.80

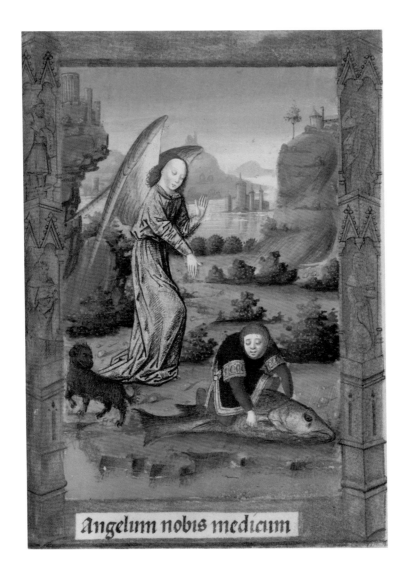

Master of Guillaume Lambert | Tobias and the Angel

Book of hours, use of Rome, fol. 186

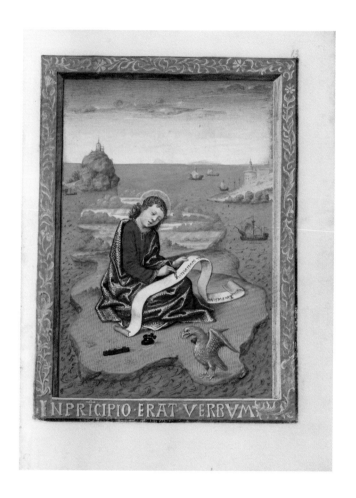

Georges Trubert | Saint John on Patmos

Book of hours, fol. 13
Provence, ca. 1480–90
Leaf: 11.5 × 8.6 cm (4½ × 3⅛ in.)
Ms. 48; 93.ML.6

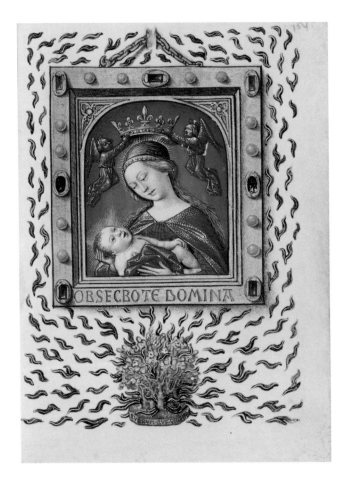

Georges Trubert | Madonna and Child and The Burning Bush

Book of hours, fol. 54v

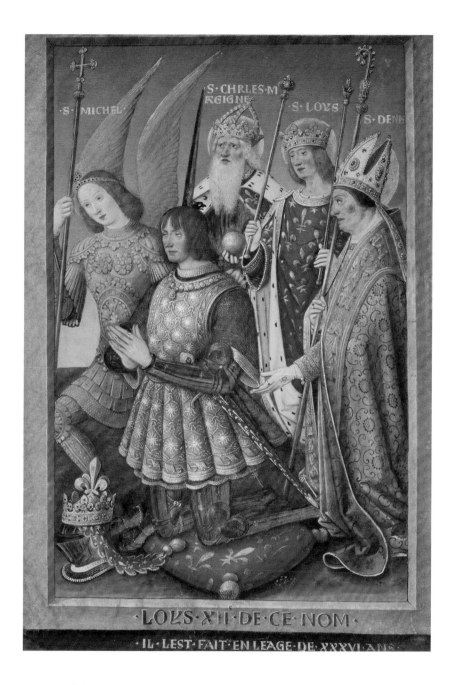

Jean Bourdichon | Louis XII of France Kneeling in Prayer

Detached leaf from the Hours of Louis XII
Tours, 1498/99
Leaf: 24.3 × 15.7 cm (9 9/16 × 6 3/16 in.)
Ms. 79a; 2004.1

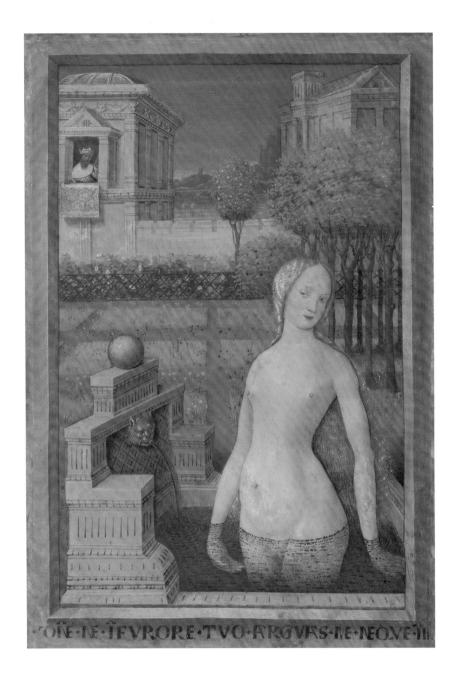

Jean Bourdichon | Bathsheba Bathing

Detached leaf from the Hours
of Louis XII and detail
Tours, 1498/99
Leaf: 24.3 × 17 cm (9 ⁹⁄₁₆ × 6 ¹¹⁄₁₆ in.)
Ms. 79; 2003.105

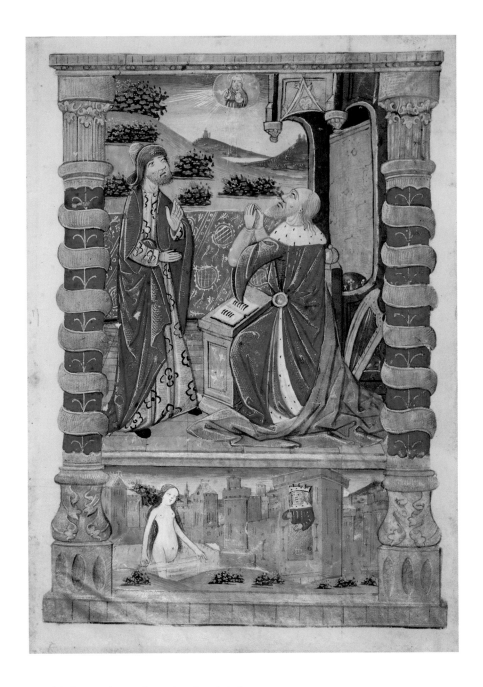

David before Nathan and David and Bathsheba

Leaf from a prayer book
Rouen, ca. 1500
Leaf: 17.6 × 12.8 cm (6 $^{15}/_{16}$ × 5 in.)
Ms. 58; 94.MS.43
Gift from the Collection of Heinz
Kisters, Switzerland

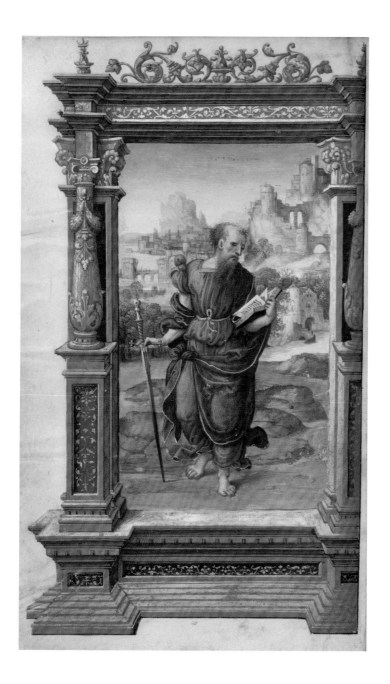

Master of the Getty Epistles | Saint Paul

Epistles of Saint Paul, fol. 5v
France, ca. 1520–30
Leaf: 16.4 × 10.3 cm (6 ⁷⁄₁₆ × 4 ¹⁄₁₆ in.)
Ms. Ludwig I 15; 83.MA.64

The Agony in the Garden

Book of hours, use of Rome, fol. 13v
Paris, 1544
Leaf: 14.3 × 8.1 cm (5 ⅝ × 3 ¹/₁₆ in.)
Ms. Ludwig IX 20; 83.ML.116

Jean Pierre Rousselet | The Raising of the Cross

Prayers of the mass, fol. 19v
Paris, ca. 1720–30
Leaf: 11.9 × 7.2 cm (4 ¹¹⁄₁₆ × 2 ¹³⁄₁₆ in.)
Ms. Ludwig V 8; 83.MG.83

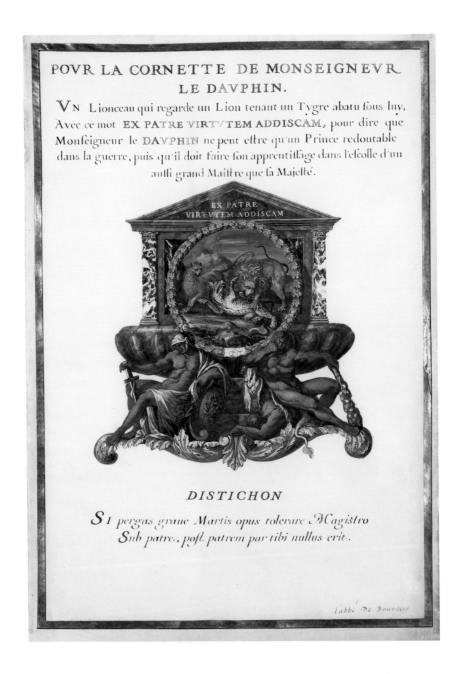

POVR LA CORNETTE DE MONSEIGNEVR
LE DAVPHIN.

VN Lionceau qui regarde un Lion tenant un Tygre abatu fous luy,
Avec ce mot **EX PATRE VIRTVTEM ADDISCAM**, pour dire que
Monfeigneur le DAVPHIN ne peut eftre qu'un Prince redoutable
dans la guerre, puis qu'il doit faire fon apprentiffage dans l'efcolle d'un
auffi grand Maiftre que fa Majefté.

EX PATRE
VIRTVTEM ADDISCAM

DISTICHON

SI pergas graue Martis opus tolerare Magistro
Sub patre, poft. patrem par tibi nullus erit.

l'abbe De Bourseis

Jacques Bailly | Design for a Device: A Lion Cub Witnessing His Father Battling a Tiger

*Leaf 4 from a manuscript of royal
devices from the court of Louis XIV*
Paris, ca. 1663–68
Leaf: 39.4 × 27.1 cm (15 1/2 × 10 11/16 in.)
Ms. 11; 85.MS.118

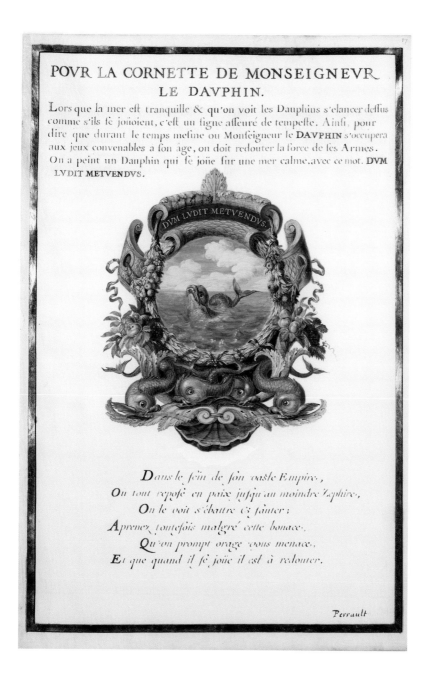

POVR LA CORNETTE DE MONSEIGNEVR LE DAVPHIN.

Lors que la mer est tranquille & qu'on voit les Dauphins s'elancer dessus comme s'ils se joüoient, c'est un signe asseuré de tempeste. Ainsi, pour dire que durant le temps mesme ou Monseigneur le **DAVPHIN** s'occupera aux jeux convenables a son âge, on doit redouter la force de ses Armes. On a peint un Dauphin qui se joüe sur une mer calme, avec ce mot. **DVM LVDIT METVENDVS.**

DVM LVDIT METVENDVS.

Dans le sein de son vaste Empire,
Ou tout reposé en paix jusqu'au moindre Zephire,
On le voit s'ébattre & sauter ;
Aprenez toutefois malgré cette bonace,
Qu'un prompt orage vous menace,
Et que quand il se joüe il est à redouter.

Perrault

Jacques Bailly | **Design for a Device: Landscape with Dolphin in Calm Waters**

Leaf 6 from a manuscript of royal devices from the court of Louis XIV

© 2007 J. Paul Getty Trust

Getty Publications

1200 Getty Center Drive, Suite 500

Los Angeles, California 90049-1682

Mark Greenberg, Editor in Chief

Patrick E. Pardo, Editor

Vickie Sawyer Karten, Designer

Amita Molloy, Production Coordinator

The author would like to thank François Avril for his advice on several attributions.

Photography and digital imaging supplied by Rebecca Vera-Martinez, Chris Allen Foster, and Michael Smith of Getty Imaging Services

Color separations by Professional Graphics Inc., Rockford, Illinois

Printed and bound in Singapore by CS Graphics Pte. Ltd.

Library of Congress Cataloging-in-Publication Data

J. Paul Getty Museum.
 French illuminated manuscripts in the J. Paul Getty Museum / Thomas Kren.
 p. cm.
 ISBN-13: 978-0-89236-858-7 (pbk.)
 ISBN-10: 0-89236-858-6 (pbk.)
1. Illumination of books and manuscripts, French—Catalogs. 2. Illumination of books and manuscripts—California—Los Angeles—Catalogs. 3. J. Paul Getty Museum—Catalogs. I. Kren, Thomas, 1950– II. Title.
 ND3147.J2 2007
 745.6'7094407479494—dc22
 2006031373